# FIRST STEPS
### S E R I E S

# Drawing in Pen & Ink

## CLAUDIA NICE

**NORTH LIGHT BOOKS**

Cincinnati, Ohio

# Acknowledgments

This book is the result of many who have helped me on my way. Susan Scheewe and Tony Murray who encouraged my beginning efforts. Greg Albert, David Lewis, Rachel Wolf, Kathy Kipp and my numerous friends at F&W Publications who have smoothed my pathway and made authorship a joy. Thank you.

Drawing in Pen and Ink. Copyright © 1997 by Claudia Nice. Manufactured in China. All rights reserved. No part of this book may be reproduced in any form or by any electronic or mechanical means including information storage and retrieval systems without permission in writing from the publisher, except by a reviewer, who may quote brief passages in a review. Published by North Light Books, an imprint of F&W Publications, Inc., 4700 East Galbraith Road, Cincinnati, Ohio 45236. (800) 289-0963. First edition.

Other fine North Light Books are available from your local bookstore, art supply store or direct from the publisher.

06   05   04            11   10   9   8

Library of Congress Cataloging-in-Publication Data

Nice, Claudia
    Drawing in pen and ink / by Claudia Nice.
      p.    cm.—(First steps series)
   Includes index.
   ISBN 0-89134-717-8 (pbk.: alk. paper)
   1. Pen drawing—Technique. I. Title. II. Series: First steps series
  (Cincinnati, Ohio)
NC905.N523   1997
741.2′6—dc21                                          96-52947
                                  CIP

Edited by Joyce Dolan
Production Edited by Kathleen Brauer and Bob Beckstead
Designed by Brian Roeth
Cover photography by Pamela Monfort Braun/Bronze Photography

# Dedication

I dedicate this book to my students,
who have inspired me more than they know.
May their enthusiasm take them far and the
joy of creation shine often upon their faces.

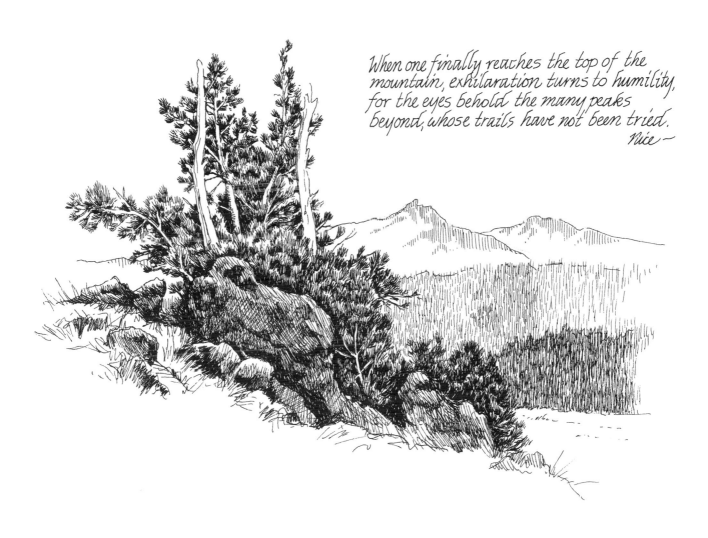

*When one finally reaches the top of the mountain, exhilaration turns to humility, for the eyes behold the many peaks beyond, whose trails have not been tried.*

*Rice —*

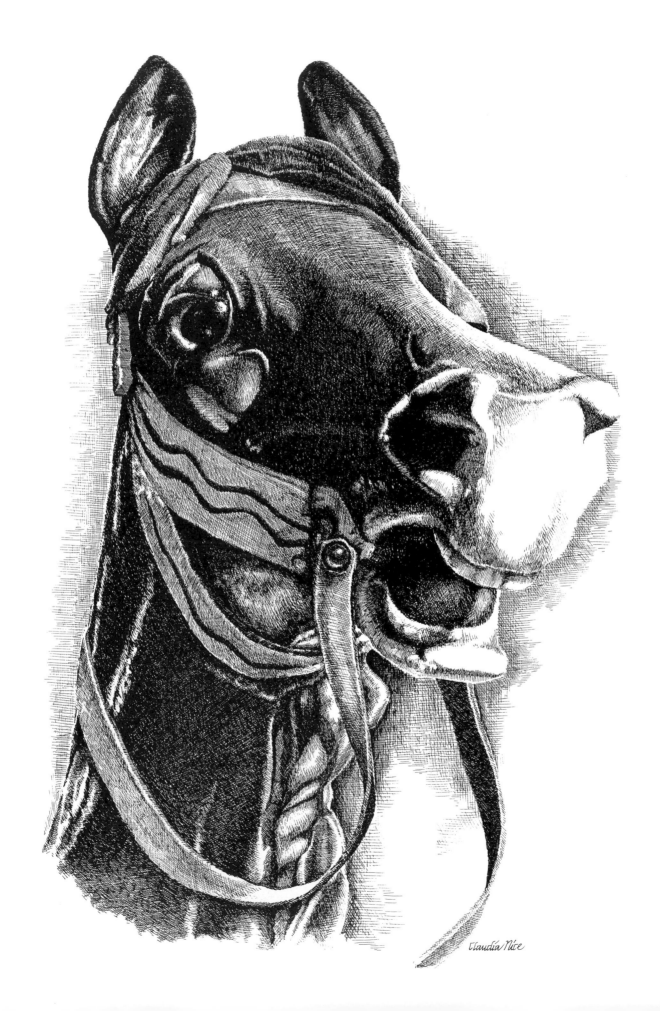

Claudia Nice

# Table of Contents

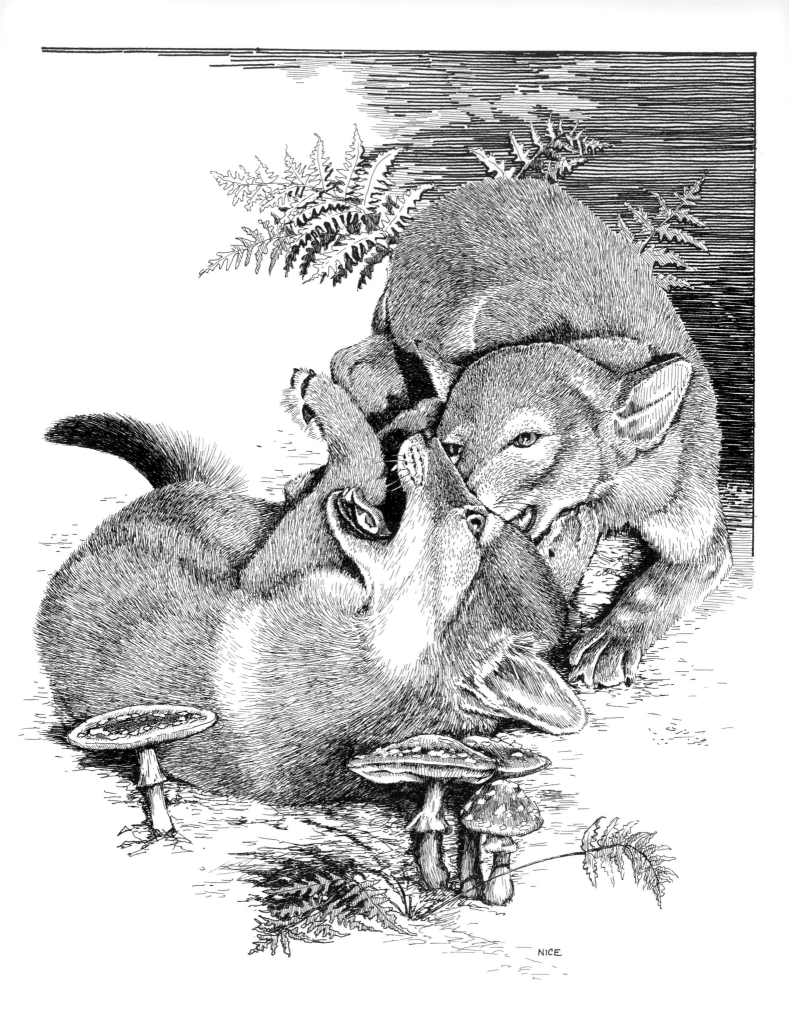

# Introduction

Everyone must start their artistic adventure at the beginning. Mine started with a box of crayons and a newsprint tablet. Grade school brought the excitement of tempera paint. In high school, I found the joys of watercolors, oils, pastels and the crow quill ink pen.

My favorite subjects were found outdoors. I carried the humble dip pen, a bottle of India Ink and a sketchbook with me into the field. And there, beneath open skies, surrounded by nature, I learned to sketch. While nature impressed and inspired me, the mistress of mistakes slowed me and showed me how to begin again. Those valuable failures were given to experience and the successes have been repeated, improved and committed to memory. From experience comes style—a bit of what the eye sees, the heart feels and the mind interprets flowing through the hand and pen, onto the paper. This to me is art.

If you have a yearning to pick up a pen and gather some creative experience of your own, there is no need to sketch alone. Through this book I would like to share and encourage your first basic steps. And if it makes your artistic pathway a little smoother, it will have accomplished its purpose. So take courage, learn to observe, feel free to experiment and above all, relax and find joy in what you do.

Best Wishes,

*Claudia Nice*

Claudia Nice

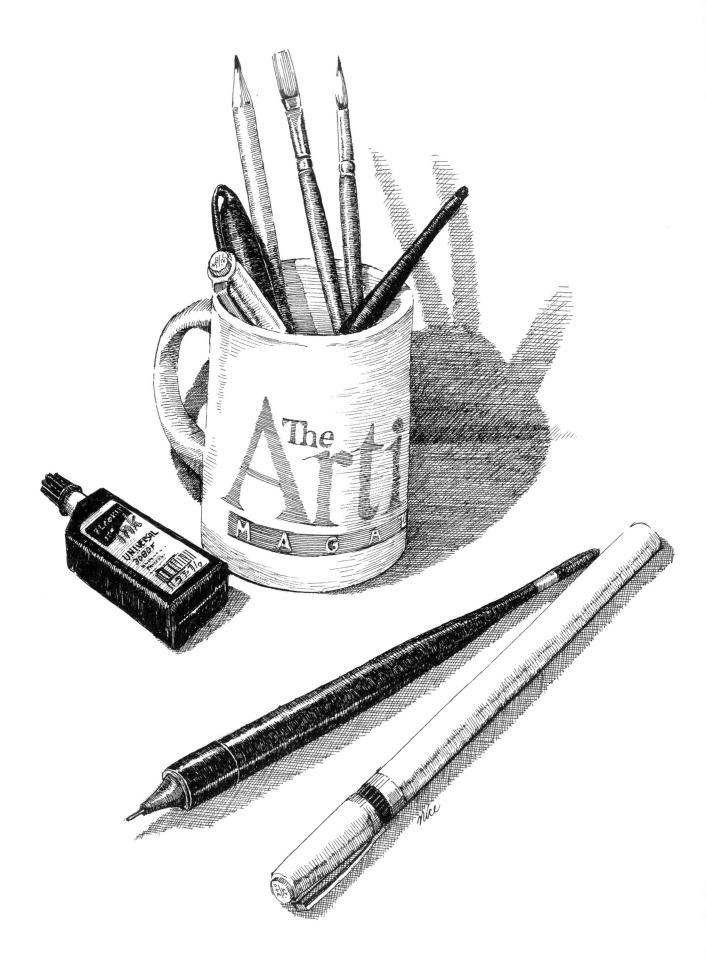

# MATERIALS

Pen, ink and paper—that's all you need to get started. The simplicity of the tools makes pen and ink the ideal medium to carry along in a purse, pocket or backpack, so when an artistic mood strikes, you're ready to sketch.

Fountain pens, felt tip markers, fiber tip pens, ballpoint pens, reeds and feather quills will all work as inking tools with varying degrees of success. More than once I have softened and frayed the end of a twig and used it to make a rough ink applicator, when I was far from my studio and my real pen was misplaced. The results were crude, but the experience was fun.

In the old days, bird feathers were the tools of choice for both writing and ink sketching. Generally duck quills were used, but when a finer line was desired crow quills were selected. The ends of the quills were sharpened to a point with a penknife. The quill tip was dipped into ink and the hollow feather shaft held enough fluid for several strokes.

Inks were also homemade. Crushed walnut shells simmered with vinegar and salt set the color. Oak tree galls brewed with iron salts produced a dark, rich tannin-based ink which was fairly permanent. Soot mixed with shellac produced the first black India inks.

The modern artist has a vast array of pens and inks to choose from. With so many variations available, what inking tools are recommended? The characteristics I look for in an ideal pen are a steady, reliable, leak-free flow and a nib that is precise and can be stroked in all directions. The inks I prefer to use are pigmented, rather than dye based, and are permanent, waterproof and brush-proof.

# The Pen

## Dip Pens

The crow quill dip pen is an adaptation of the early feather quill dip pens. It consists of a wooden or plastic holder and a removable steel nib. With Hunt nibs no. 102 (medium) and no. 104 (fine), the crow quill will provide a good ink line. The tool cleans up easily and is inexpensive. It's useful for applying colored inks when you want many color changes. However, crow quills are limited in stroke direction, with a tendency to drip and spatter. The redipping process interrupts the stroking rhythm.

## Markers

Felt-tip and fiber-tip pens are great for quick sketching because you do not have to wait for the ink to flow down the nib. A good marker is able to keep pace with even the fastest hand. Markers are available in a variety of colors, nib shapes and sizes, and degrees of permanence. They are convenient and economical.

There are a few drawbacks. Markers tend to "dry up" at the most inopportune times, with little warning. You must always have a backup handy. Markers are not capable of producing extremely fine lines, and are not made to be a replacement for the more precise steel-nibbed pens.

## Technical Pens

I consider the technical pen the best inking instrument available. It is an advanced drawing instrument, consisting of a hollow metal nib, a self-contained ink supply (either a pre-filled or refillable cartridge) and a plastic holder. Within the hollow nib is a delicate wire and weight which shifts back and forth during use, bringing the ink supply forward. This wire should not be removed from the nib.

The nibs are made out of steel and are quite durable on paper surfaces. More expensive jewel points and tungsten points are available for more abrasive surfaces. Because the hollow technical pen nibs are circular in design, they can be stroked in any direction, and are ideal for stippling. The resulting dots and lines are precise and can be as narrow as 0.13 mm, depending on the nib size chosen. When properly maintained, the technical pen is reliable and provides a consistent, leak-free flow.

Of all the styles and brands of technical pens available, my favorite is the Koh-I-Noor Rapidograph. I have found it dependable, and the refillable cartridge allows me to choose my own ink.

On the downside, technical pens are the most expensive of all the ink application tools. Like any fine instrument, they require cleaning and maintenance, and will clog if neglected or abused.

Disposable technical pens are similar in usage to regular technical pens. They differ somewhat in design, in that the inner workings are sealed and the prefilled cartridges are not refillable. They are less expensive than traditional technical pens and require little or no maintenance. However, prefilled ink cartridges do not allow the artist choice of ink and may contain inks that are not permanent. For a dependable, disposable technical pen, I recommend the Grumbacher Artist Pen. It contains a permanent India ink that can be brushed with watercolor washes after fifteen minutes of drying time.

## Nib Sizes

Technical pens come in various nib sizes ranging from very fine to extra broad. Nib sizes 0.13 mm to 0.25 mm provide a delicate to fine line, good for detail work. Nib sizes 0.30 mm and 0.35 mm provide a medium line that's nice for making quick sketches, creating texture and detailing larger drawings. Nib size 0.50 mm provides a heavy line that is good for bolder techniques and fill-in work. Larger nib sizes are handy to create big, black solid shadows and backgrounds. My favorite all-around pen is the 0.25. It's fine enough for detail work, yet can produce nice texture and value changes.

In this book, I have indicated the nib sizes used by placing the numbers in parentheses beside the drawings.

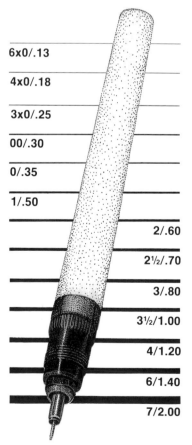

6x0/.13
4x0/.18
3x0/.25
00/.30
0/.35
1/.50
2/.60
2½/.70
3/.80
3½/1.00
4/1.20
6/1.40
7/2.00

# The Technical Pen

The following information on use, care and maintenance of a technical pen refers directly to the Koh-I-Noor Rapidograph, but will be useful for other brands of technical pens as well, many of which are similar in design.

## Filling the Pen

To fill the pen, the Rapidograph is disassembled down to the ink cartridge. The ink is poured down the inner edge of the ink cartridge slowly to avoid the formation of a large bubble. Stop pouring just before reaching the fill line (¼" [0.6cm] from the top). Reassemble the pen except for the cap.

The best way to start a Rapidograph pen is to hold it, nib upright, and gently thump it to let excess air escape. Turn the pen, nib pointing downward, and wait thirty seconds for the ink to flow to the nib. Tap the end of the holder to bring the ink through to the tip. This eliminates bubbles that form when the pen is shaken.

## Using the Technical Pen

Hold the pen as you would a pencil, keeping the angle rather upright. Technical pens are gravity fed. Use a steady, light pressure, maintaining good contact with the drawing surface. Too much pressure will inhibit ink flow. Stroke slowly, allowing the ink flow to keep pace with your hand.

As the pen travels across the paper, you'll be able to feel the wire within the hollow nib. This is normal.

Do not shake the Rapidograph. Most clogging problems occur when the air channel is flooded, creating a vacuum that prevents the ink flow. Flooded pens must be cleaned. Keep the cap on when not in use.

On the other hand, Grumbacher Artist Pens are designed to be shaken or tapped against the edge of a table to stimulate ink flow. When in doubt, read the directions.

## Cleaning the Pen

Clean the technical pen at least once a month for maintenance and before storage of more than a month. If it clogs, clean it!

To clean the Rapidograph and similar pens, disassemble the pen and remove the nib from the body of the pen. *Do not remove the wire from the nib.* Rinse the nib, pen body and cartridge under running water. You will need a pen cleaning solution to remove dried ink and shellac. Several commercial varieties are available. In a pinch, use a diluted solution of ammonia or alcohol. However, this is not recommended for constant usage. A pressure cleaning syringe, threaded to accept the pen nib, is very helpful in flushing out the old ink and cleaning solutions. Ultrasonic cleaning machines work well, but are more expensive.

## Troubleshooting the Technical Pen

*Ink flow stops suddenly*—Usually caused by bubbles trapped in the nib. Tap the holder vertically against the table to settle the ink.

*Pen skips*—Not enough hand pressure, strokes are too fast, the nib is dirty or the pen is low on ink.

*Pen bleeds*—Caused by temperature change, altitude change, low amount of ink in cartridge or a dirty nib.

*No ink flow*—Pen is clogged, wire is damaged or the pen is out of ink.

*Nib snags*—Caused by worn nib or inappropriate surface.

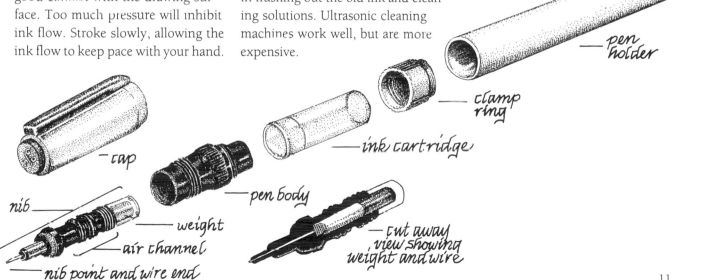

pen holder

clamp ring

ink cartridge

cap

pen body

nib

weight

air channel

nib point and wire end

cut away view showing weight and wire

# Ink

Be aware that inks not recommended for technical pens will result in clogs.

## India Ink

Modern India inks are composed of water; finely ground carbon particles for rich, black color; and shellac or latex for a binder. Different blends of these ingredients determine the ink's opacity, open pen time, surface drying time, adhesion and permanence.

Very black, opaque inks have a higher ratio of pigment in the mixture. Such inks give the greatest amount of contrast and create lines that reproduce well. Heavily pigmented inks may not flow as well in nib sizes 0.13 and 0.18.

India inks labeled "permanent" should hold up under high humidity

---

## Open Pen Time

*Open pen time* is an important factor when selecting the proper ink for your pen. It refers to the amount of time the ink will remain fluid in an open, inactive nib. (Pens should be capped when not in use.) If you use a 0.25 nib or smaller, in a dry climate, choose a free-flowing ink with a longer open pen time.

---

situations, adhering well to the paper surface when touched with damp fingers. However, even "waterproof" inks may smear when overlaid with brush applied washes of watercolor, acrylic, diluted inks or oil paint. Test your ink to see if it is "brush proof" before applying any type of wash to your sketch. On a scratch piece of paper, lay down a heavy concentration of ink lines. Let dry 15 to 30 minutes. Then test it by brushing vigorously with a soft watercolor brush and water. If the ink stays put, it's brush-proof.

My favorite for 0.25 and larger is Koh-I-Noor's Universal Black India (3080). It's a versatile, high opacity ink that is free-flowing, fast drying and brush-proof.

Koh-I-Noor's Ultradraw (3085) is a very black ink with a good open pen time, which is ideal for finer nibs. Although this ink is not completely brush-proof, lines stroked from a 0.18 or 0.13 nib may be overlaid *lightly* with washes, without noticeable bleeding.

India inks are numerous. Experiment with various brands and types to determine your own personal favorite. India inks do have a shelf life of one to five years, depending on the makeup. Old inks separate and should be disposed of in an environmentally safe manner.

## Colored Inks

Dye-based, colored inks have a tendency to fade over a period of time. Check the label for color fastness before filling your pen for a detailed, lengthy project. For a brown (Sepia) tone or colored ink, I recommend Koh-I-Noor's Drawing Ink #9065. It is a finely pigmented, transparent, liquid acrylic that can be used in technical pens. Because it is brush-proof, it can be applied both under and over washes of brushed-on color.

## Liquid Paper

Liquid Paper for Pen and Ink is useful for correcting small mistakes, or for making large corrections on art that is meant for reproduction only. To avoid clogging nibs, let the correction fluid dry for five minutes before inking over it. Lines appear narrower on the liquid paper, so move up one nib size when making corrective strokes.

There is no effective way to *remove* ink from drawing paper. Large mistakes usually mean starting over or disguising the mistake under additional ink lines.

# Ink Washes

Unusual contrasts in texture and value can be achieved by combining pen-and-ink stroke work and ink-and-brush painting. This procedure requires a water-absorbent surface such as heavy drawing paper or, better yet, a cold-press watercolor paper.

India ink, fountain pen ink, transparent liquid acrylic or watercolor may be used for the washes. Pen work will stroke easily over all of these mediums and if you use a brush-proof ink in your pen, the washes may be overlaid. Try to match the black or

Sepia inks used in your pen with the color selected for the wash. Payne's Gray washes will match bluish black inks, while mixtures of Umber, Sepia and black washes will complement a brown or warm black ink. Or simply dilute the ink in your cartridge for a perfect match. Control the darkness of the wash by varying the amount of water added.

A no. 4 round watercolor brush and a ¼" (0.6cm) stroke brush work well for applying washes to small projects. If you're using diluted India

ink for your wash, you may have to use a solvent to clean your brush.

**Liquid frisket** is used while washes are applied to mask out or protect areas of a painting not to be washed. Use a synthetic-hair brush to apply the frisket. Dip the brush in liquid soap first and it will help with cleanup. Remove the liquid frisket from the work surface with an eraser.

Ink wash on dry paper (Drybrush Technique).

Dark India Ink wash.

medium India Ink wash overlaid with pen work.

Light India Ink wash brushed over pen work.

Layered India Ink washes. Each layer was dry before the next wash was brushed on.

Blended India Ink wash. Use clean, damp brush to blend moist washes together.

Wet-on-wet. India ink brushed on wet surface.

Pen, ink and wash
examples, painted
on 125lb, cold-pressed
Watercolor paper.

The cat's fur was stroked in
using a .25 Rapidograph filled
with Universal Black India
Ink.

A "mock" ink wash of Warm
Sepia & Lamp Black
(Grumbacher) water colors
was brushed over
the ink work.

Dry brush
wash in
ears, over-
laid with
pen work. →

Eyes are a
damp surface,
blended
wash.

Criss cross
pen strokes →

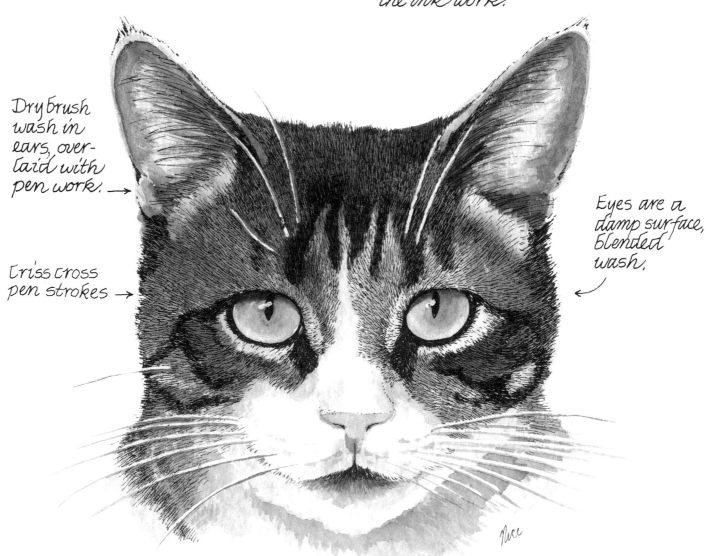

Nicc

Whiskers were
masked out with
liquid frisket.

↖ Layered wash

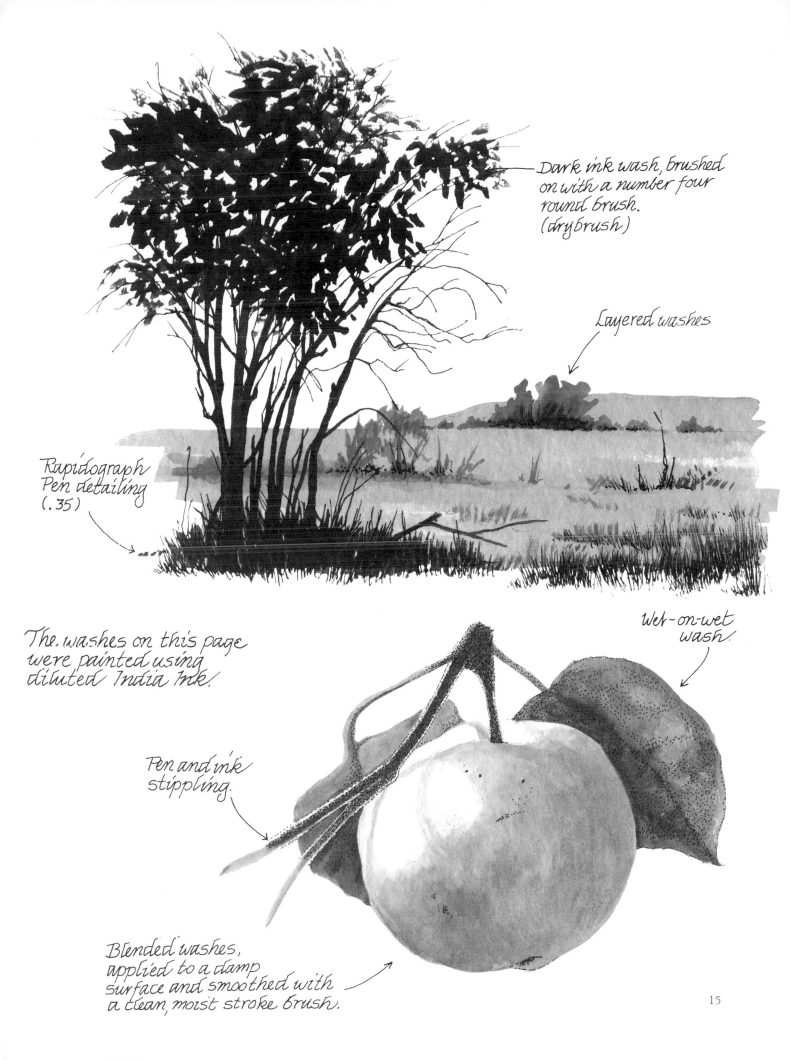

Dark ink wash, brushed on with a number four round brush. (drybrush)

Layered washes

Rapidograph Pen detailing (.35)

Wet-on-wet wash.

The washes on this page were painted using diluted India Ink.

Pen and ink stippling.

Blended washes, applied to a damp surface and smoothed with a clean, moist stroke brush.

# Inking Surfaces

An absorbent paper with a firm polished texture provides the best surface for pen and ink. The pen should glide over the paper without snagging, picking up lint or clogging. The ink should neither bleed nor bead up as it is applied. The resulting line should be sharp-edged and precise in appearance.

## Art Boards

Hot-press illustration board is a personal favorite of mine for highly detailed projects that are intended to be matted and framed. The outer face is very smooth, yet highly absorbent. Even the finest nibs flow readily over its surface. Ink lines applied to hot-press illustration board may be lightened by gently scraping them with a new razor blade.

Cold-press illustration board has a less polished texture that allows the ink lines to lose some of their sharpness. The result is a softer appearance which complements some subjects.

Claybord has a thick surface coating of kaolin clay. The fine-tooth finish is very forgiving, allowing the complete removal of ink lines with a razor blade. It accepts washes, which can be lightened and blended by rubbing with artist grade steel wool. However, the resulting clay dust can clog pens if not removed completely.

## Bristol Boards

Bristol boards provide a very smooth surface and come in various thicknesses, ranging from very stiff to the flexibility of card stock. Most bristols readily accept ink lines, but I have experienced a bleeding problem in some brands. Crescent Hi-Line LX Series, No. 383 works quite well.

Scanner board (No. 59208 by Crescent) has a precision work surface, designed to peel away from the board for laser scanning and reproduction, then re-sticks to the board surface for storage or framing.

## Mylar

Mylar is often chosen as a work surface when the artist needs very precise lines for reproduction. However, it is quite abrasive and can wear down a steel nib quickly. If you work on mylar, choose a jewel or tungsten nib.

## Papers

Drawing paper is the most economical surface for the beginner to get in lots of inking practice. Papers are thinner and softer than bristols. A frayed line is a good indication that the paper is *too* soft for ink work. There are many grades and varieties so experiment to see which of the available papers are compatible to your pens and techniques. Rapido-graph Pen and Ink Paper (Koh-I-Noor No. 3165) and Meridian Drawing Paper (Grumbacher No. 01606) are two reliable papers. Most of this book was sketched on Meridian paper.

Parchments and vellums provide a fun alternative to traditional paper surfaces, and usually work quite well.

## Watercolor Paper

Watercolor paper is a good choice to experiment with a combination of ink line work and washes of transparent acrylic, watercolor or diluted ink. I prefer a cold-press watercolor paper, because the surface tends to be more polished and easier to ink over. Rapidograph Paper for Pen and Ink and Watercolor Wash (Koh-I-Noor 3165WC) is my favorite. However, there are many excellent watercolor papers and boards that warrant experimentation.

## Textured Surfaces

Although pens were designed for paper, I have inked successfully on glass, portrait grade stretched canvas, film, sealed wood, leather and polished rock. Almost any smooth surface is fair game—just use a light touch and an adventurous outlook. If the pen skips, bleeds, clogs or drags, consider the surface not compatible.

# Bound Sketchbooks

For quick sketches, field studies and artistic recordings, I like to work in a bound sketchbook. Sketchbooks come in both portrait and landscape formats and are available in a variety of sizes, the smaller ones of which can be tucked in a purse, knapsack or camera bag. Because the pages are bound, sketches are less apt to be torn out, lost or given away to admirers. Most quality sketchbooks contain a paper that works well for both pen and ink, and light watercolor washes.

I use my sketchbook as an artistic journal, recording memories, sketching scenes, capturing details of nature and documenting interesting shapes, textures and backgrounds that may prove useful later on. Since it is a "journal," I may choose to keep it strictly personal or pass it around for others to view. I never apologize for the drawings within, no matter how roughly executed.

Beside my sketches, I include field notes that point out and recall interesting features of the subject I drew. These might include colors, sizes, textures, smells, sounds and other physical characteristics. I also record the date, place, subject and circumstances of the drawing. I may comment on the weather, the terrain and my personal feelings at the time.

Some of these journal entries have become the basis of more refined drawings and paintings, or have preserved valuable details my mind no longer remembered. Should it serve no other purpose, the sketchbook journal will be an intimate treasure, a bit of yourself, bound up and preserved like a personal time capsule.

white to cream —

rich black —

Bamboo →

Ling Ling - Panda

National Zoo Washington D.C.

April '89

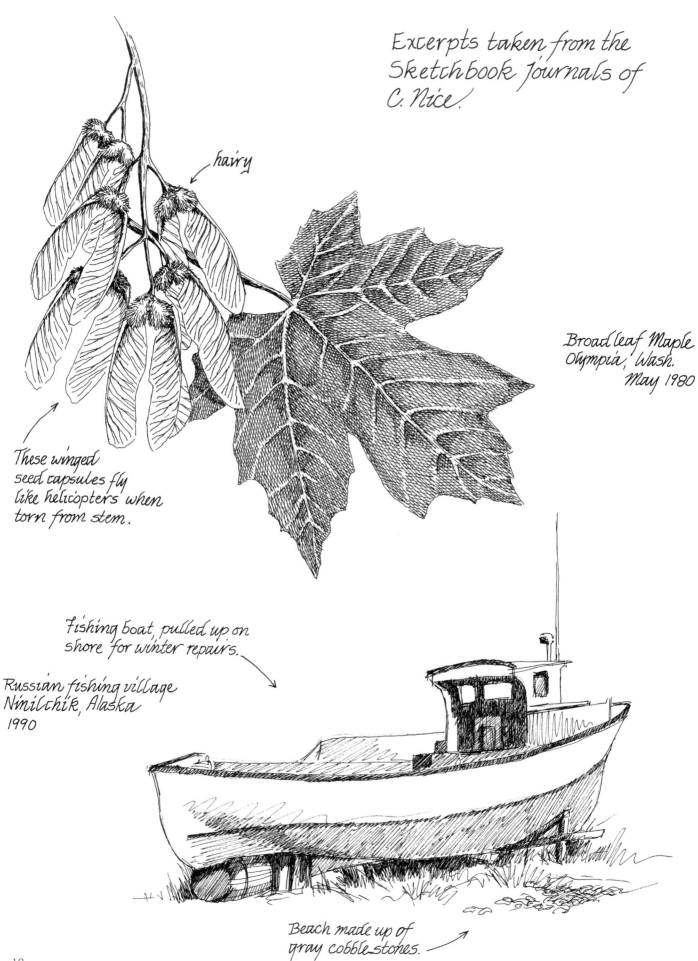

Excerpts taken from the Sketchbook Journals of C. Nice.

hairy

Broad leaf Maple
Olympia, Wash.
May 1980

These winged seed capsules fly like helicopters when torn from stem.

Fishing boat, pulled up on shore for winter repairs.

Russian fishing village
Ninilchik, Alaska
1990

Beach made up of gray cobble stones.

Mallard ducks have a V-shape where forehead meets beak!

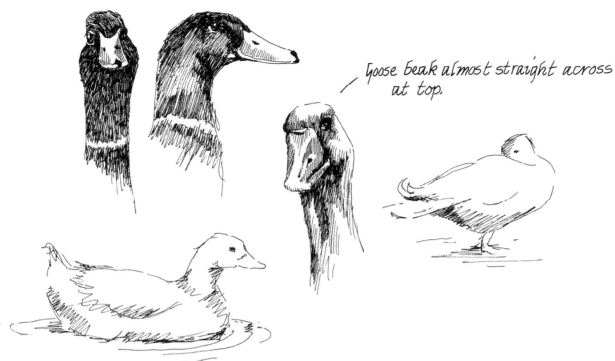

Goose beak almost straight across at top.

Duck and goose study
College duck pond
Gresham, OR
1987

Bison
Wildlife preserve
Delta Junction, Alaska - '87

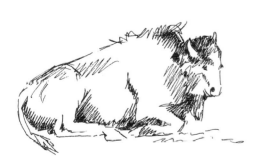

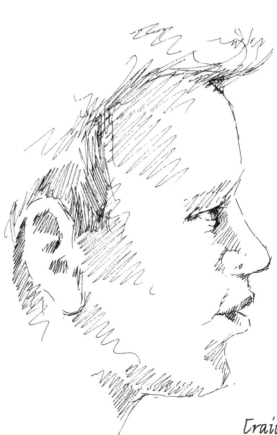

Craig
Tucson sales meeting
1994

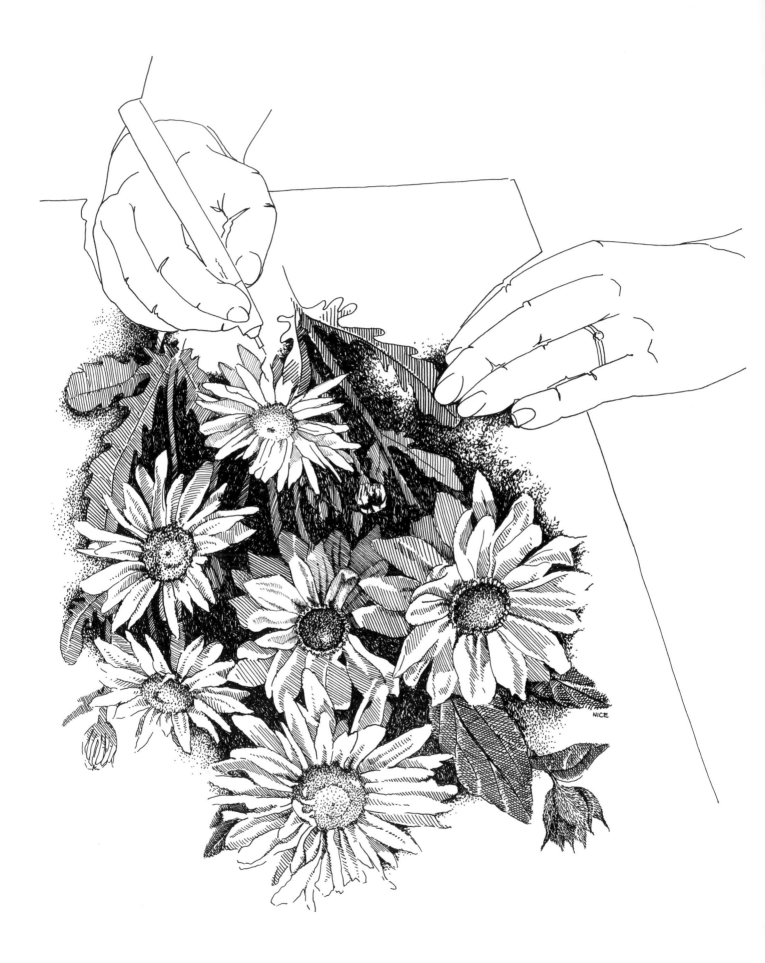

*Chapter Two*

# BASIC TECHNIQUES AND EXERCISES

A pen-and ink sketch is simply a series of marks set down on paper to resemble something the eye can recognize. There are basically two kinds of marks the artist can create—dots and lines.

Dots are easy—touch the tip of the pen to the paper, lift straight up and you have one. Hundreds of dots can be grouped together to form shapes. Lines are more varied. They can be long or short; straight, curved or looped; and continuous or broken.

The best way to gain control of the pen is to practice making dots and lines in all their variations. Don't worry about creating shapes and subjects just yet; let those lines flow from your hand through the nib of the pen until you "master the movements."

The pen control exercises on the following pages will help. When you can lay down skip-free lines in precise, flowing movements, just the way your mind envisioned them, you are ready to put those lines to work.

The next step is to use those dots, lines and loops to create a design. It can be as simple as a box or a circle, or as complicated as an animal in motion. When the drawing consists of a simple outline that defines the general shape of the subject, you have a "line drawing." The outline of the hands on the opposite page is one example of a line drawing. The main emphasis of a line drawing is simplicity of form. This is a fast, fun way to use the pen to capture the essence of a subject because accuracy and realistic details are not important. Just go with the flow of the pen and let your mind and hand create, uninhibited by how it compares to reality. If the result is childlike in appearance, great! After all, children have the most fun as artists!

Step three requires adding detail and dimension to your drawings. By changing the size, volume and arrangement of the pen marks—and in the case of lines, their form—you can create the appearance of texture, highlights and shadow. There are seven distinct texturing techniques: contour lines, parallel lines, cross-hatching, dots or stippling, scribble lines, wavy lines and crisscross lines. Each of these texture groups and their many variations will be dealt with separately in this chapter.

The pen-and-ink artist has the choice of using only one texturing technique in the sketch or using several or all of them in one composition. Textures can be layered one over another to produce countless additional effects.

The ink marks each artist chooses to use and the way in which he arranges and combines them will constitute the artist's style. Textures and techniques that work well for the artist will continue to be used and expanded. Disappointing results are likely to be discarded, never to be repeated. In this way, the artist grows in ability, confidence and personal style. Don't be afraid of failures and mistakes, they are merely stepping-stones in this process. So pick up the pen and begin. Artistic adventure is only a pen stroke away.

# Pen Control Exercises

Begin by drawing a continuous wavy line, moving the whole hand across the page as needed. Move as slow as necessary to maintain good pen to paper contact and a skip-free line. (Left-handers, change the slant of the waves or turn the paper upside down.)

Draw a continuous series of loops, varying the size of the loops. Move the whole hand slowly across the page.

Now, plant your hand and, using finger movement only, practice some controlled, uniformly sized loops and waves.

Turn the paper upside down and try it again! Vary the slant. You will find that your hand has better control moving in one direction. Turning the paper upside down is an easy way to form curved lines which lean in the opposite direction.

Practice some single stroke curves. Turn the paper upside down as needed.

Try some straight vertical lines of varied lengths. You may wish to lay down some pencil guide lines with a ruler, but keep the ink strokes freehand.

Draw two horizontal pencil lines about ½ inch apart and practice starting and stopping on the pencil marks.

Draw another set of horizontal pencil guide lines and try some diagonal lines. Vary the slant, turning the paper as needed to work comfortably.

Lines drawn horizontally tend to curve downward.

For straighter horizontal lines, turn the paper sideways and draw them vertically.

Now test your pen control with the combined stroke exercises shown above.

# Seven Basic Stroking Techniques

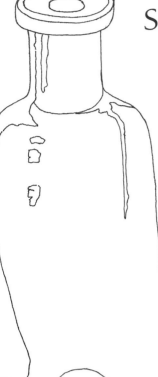

<u>Line drawing</u> ←

Shape, shadows and highlights are suggested with a simple outline.

← Texture is not shown!

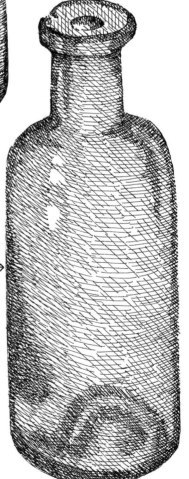

<u>Contour lines</u>

Smoothly drawn lines that seem to wrap around the surface of the object they are depicting.

<u>Parallel lines</u> →

These lines should be as straight as the human hand can draw them and extend in the same direction, at the same angle.

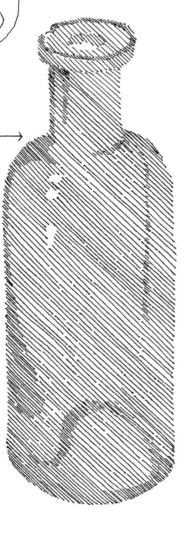

<u>Crosshatching</u> →

Two or more sets of contour or parallel lines that are stroked in different directions and intersect.

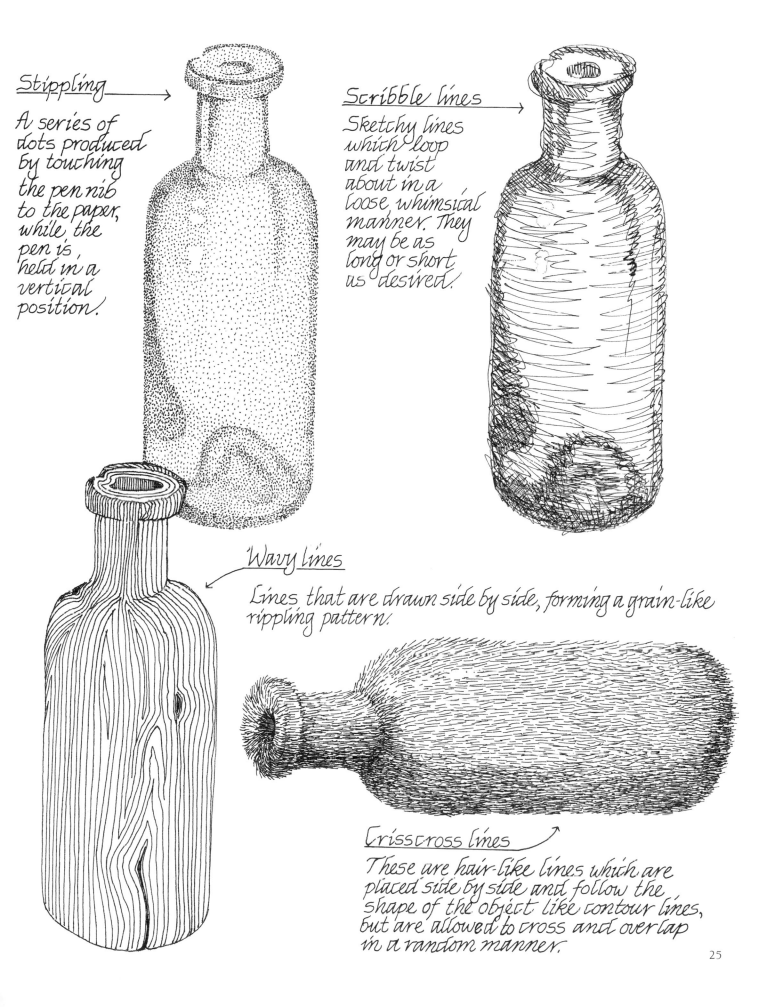

**Stippling**

A series of dots produced by touching the pen nib to the paper, while the pen is held in a vertical position.

**Scribble lines**

Sketchy lines which loop and twist about in a loose, whimsical manner. They may be as long or short as desired.

**Wavy lines**

Lines that are drawn side by side, forming a grain-like rippling pattern.

**Crisscross lines**

These are hair-like lines which are placed side by side and follow the shape of the object like contour lines, but are allowed to cross and overlap in a random manner.

# Contour Lines

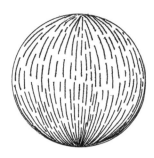

Contour lines work well to depict smooth, rounded objects and can give fluid subjects the appearance of motion.

Use for —
- polished surfaces
- metal
- glass
- flowing water

Marks may be straight or curved, long or short, and are arranged side by side following the shape of the object.

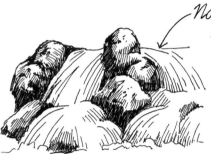

Note how falling water follows the contours of the underlying rocks.

Polished surfaces have strong highlights and abrupt value changes.

Objects seen through curved glass will appear distorted.

Avoid check marks or "hooks" by lifting the pen abruptly after each stroke.

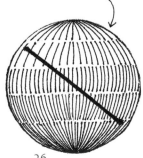

Avoid arranging contour lines in even rows.

Highlights (light values) — lines are spread out or absent.

Shadows (dark values) — lines are moved closer together or overlapped.

# Parallel Lines

Parallel lines give a subject a flat, smooth appearance. When used without an outline, these lines provide a faded, hazy or distant look.

Use for —
- flat, even surfaces
- background subjects
- objects obscured by rain, fog or poor lighting

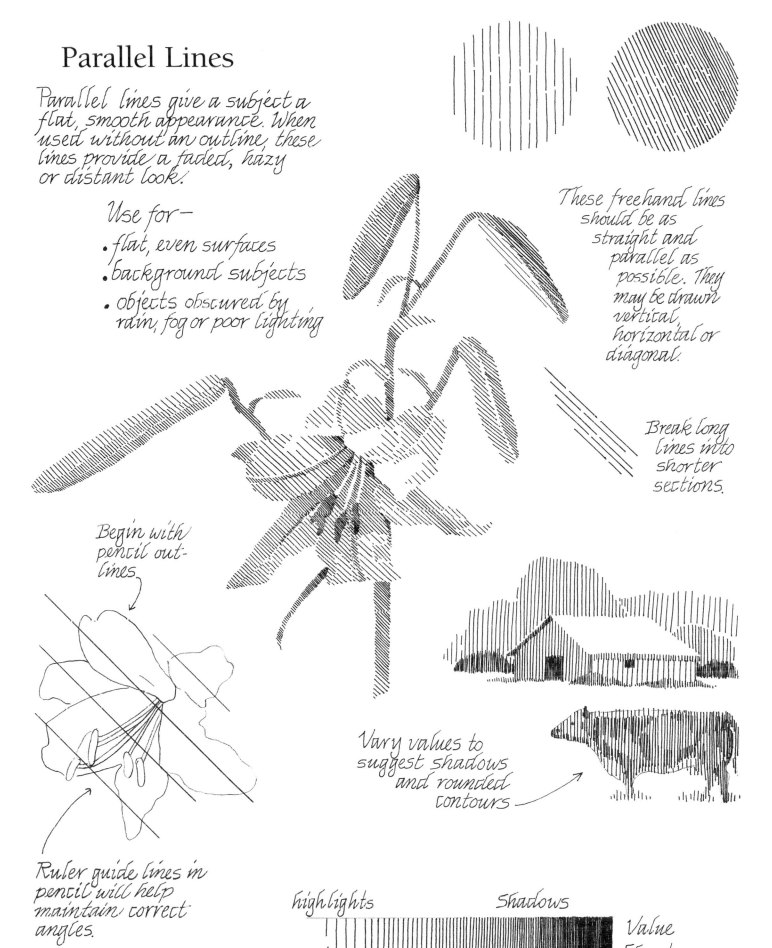

These freehand lines should be as straight and parallel as possible. They may be drawn vertical, horizontal or diagonal.

Break long lines into shorter sections.

Begin with pencil out- lines.

Ruler guide lines in pencil will help maintain correct angles.

Vary values to suggest shadows and rounded contours

highlights          Shadows

Value Chart

# Crosshatching

Crosshatching can produce a wide variety of textural effects ranging from semi-smooth to very rough, depending on the angle at which the lines intersect, the size nib used and the precision of the strokes.

Use for ~
- adding roughened texture
- deepening shadows

Crosshatched contour lines are good for rough, rounded objects.

Crosshatch lines that intersect at right angles suggest a look of strength and stability.

Use for ~
- coarse woven fabrics
- wire screening
- shadowy background shapes
- distant masonry

Lines may be long or short, precise or sketchy.

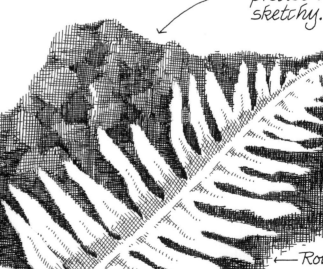

← Rough granite background

28

Parallel line crosshatching produces a flat, rough appearance.

When three or more sets of precise intersecting lines are used, dense geometric patterns are formed. This "honeycomb" crosshatching is useful for deepening shadows and covering mistakes.

(.18 nib)

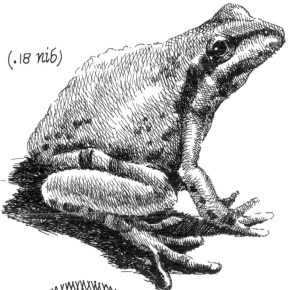

Loose, sketchy crosshatch lines provide a very rough texture. ———>

← Lines that cross at less than a 90° angle may have a scaly, shimmery or almost smooth appearance. The smaller the angle, the smoother the look.

(.35 nib)

Use for~

. skin texturing, wrinkles and deeply veined leaves

. lizard and fish scales

. objects with a semi-rough to rough texture.

hatch marks

crosshatching

honeycomb crosshatching

value chart

# Dots or Stippling

Dots work well to depict subjects composed of numerous small particles, delicate transparent objects or to give any subject a dusty, antique look.

Use for –

- sand, soil and rust
- clouds, mist and water spray
- velvet and flower petals
- delicately textured, transparent subjects such as insect wings
- nostalgic subjects such as antique cars or sailing ships
- detailed studies requiring subtle value changes
- gritty, abrasive building materials like bricks or adobe

Stippling marks should be dot-like in appearance and may be arranged in patterned formations or randomly spaced.

This delicate jellyfish was stippled using a .25 nib. Larger nibs will provide a gritty texture.

extra fine .25

fine .35

medium .50

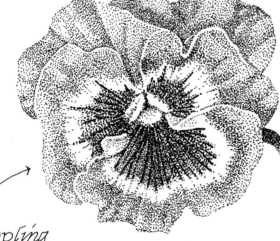

Stippling allows the artist to create subtle blends of value. The addition of each dot darkens the value ever so slightly.

value chart

shadows                          highlights

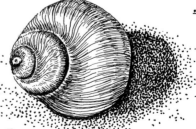

Semi-smooth snail shell contrasted against coarse, stippled sand.

# Scribble Lines

When used as a texturing technique, scribble lines create a thick, matted look. Drawn in a quick, loose manner, they are ideal for quick sketch studies.

Use for ~
- foliage and undergrowth
- curly hair and wool
- tree bark and moss
- textile designs
- sketch book quick studies

Scribble lines may be long or short, looping about in an unfettered, sketchy manner.

tangled, soft look

wiry appearance

stylized scribbled designs

← Scribbled quick sketches are not meant to be photo perfect, but should suggest shape, shading and some texture, capturing the essence of the subject.

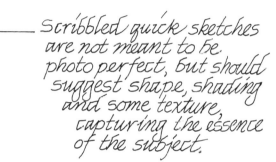

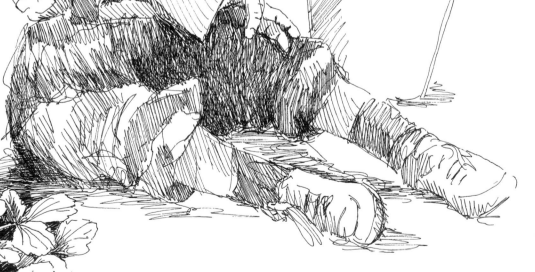

value chart

# Wavy Lines

Wavy lines are useful for depicting repetitive grainy patterns.

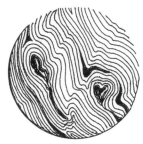
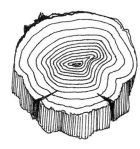

Use for ~

· woodgrain

· mineral patterns in marble, malachite, agate, etc.

· tree and water rings

· feather barbs

· repetitive leaf vein patterns

· long wavy hair

Wavy lines are long, flowing marks drawn side by side in such a manner as to form a rippling pattern.

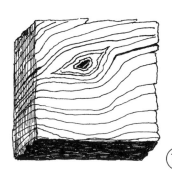

Tree ring ~ (work from the outside to the center.)

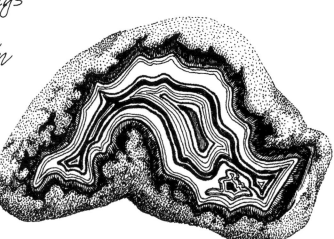

As seen in this banded agate sketch, wavy lines may be filled in solid or textured with other techniques.

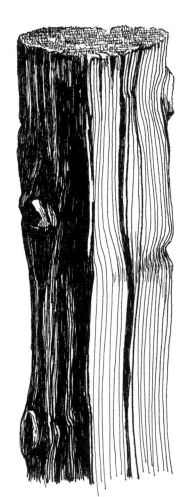

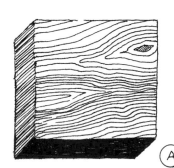

(A.)     (B.)

When using wavy lines to suggest a grain pattern, add shadows by using a second set of contour or parallel lines. Shading in the same direction as the grain provides a smooth look (example A). Crosshatching against the grain will roughen the appearance of the wood (example B).

# Crisscross Lines

Crisscross lines provide a grasslike or hairlike appearance.

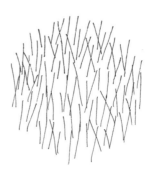 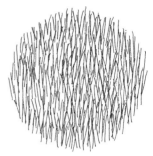

Use for ~
- short hair or animal fur
- grass or weed patches
- thatched roofs or hay stacks
- bird body feathers

Crisscross lines are randomly placed, each mark at a slightly different angle than the one beside it and uneven in appearance.

Hair direction is changed slowly, in a blended manner.

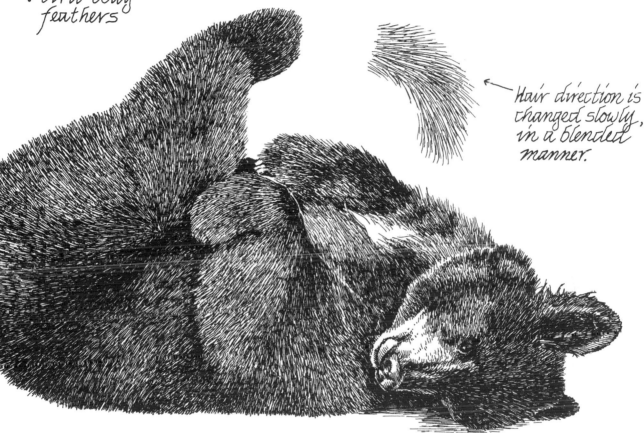

Crisscross lines may be short and straight or long and curved as seen in this wild grass sketch.

Arranging crisscross hair strokes in "rows" lends an unnatural look to fur.

Value chart

white hair                    dark hair

33

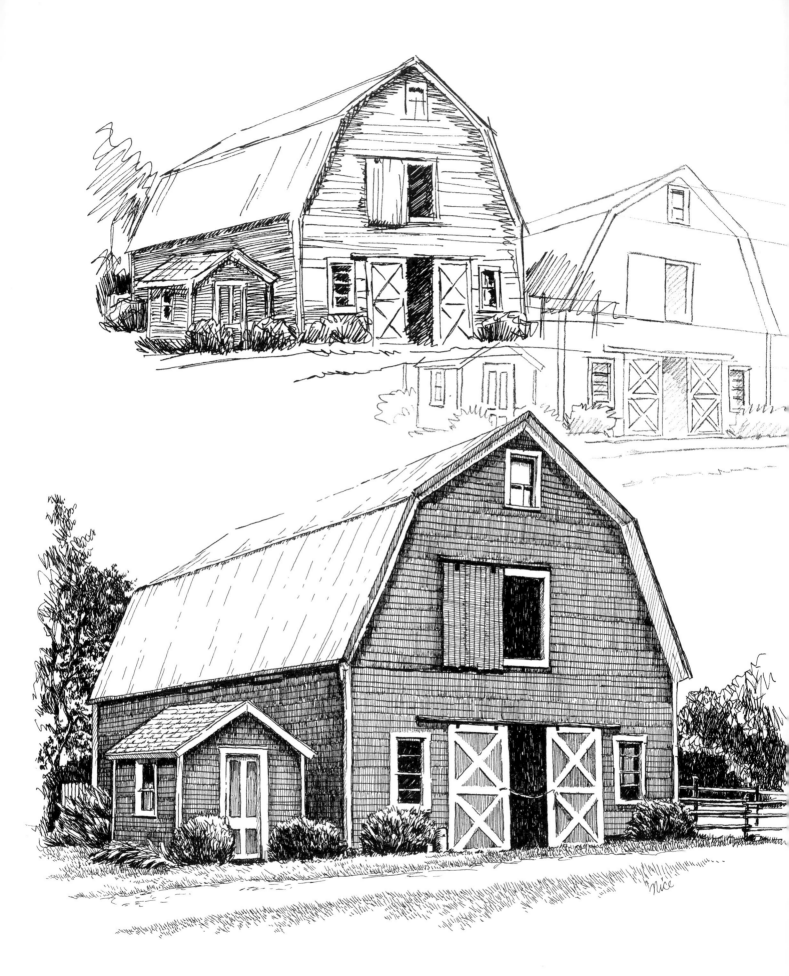

# SKETCHING

With the basic pen and ink strokes well practiced, you are ready to begin sketching. There are two basic approaches. You could jump right in freestyle and create a pen and ink "quick sketch." Spontaneous pen work is often rough, with all the mistakes highly visible; but it can please the eye because of its imperfections. Like a wild mustang among groomed show horses, an untamed ink line can appeal to our sense of freedom and adventure

On the other hand, when pen and ink drawings must appear visually correct in both form and detailing, some preplanning needs to take place. I begin these more refined drawings in pencil. Although the pencil work shown in this book is dark to be more visible, most of my preliminary sketches are done very lightly. This is the time to perfect the form and overall design, making any necessary changes before committing the drawing to ink. Shadows are lightly shaded and highlights outlined to protect them. When it's time to pick up the pen, the homework has already been done and there's nothing left but to have fun with the stroke work.

Whether your work is spontaneous or precise, success still depends greatly on your ability to "see" what you are drawing. Take a walk, open your eyes and notice what you've never seen. Erase the preconceived forms outlined in the mind's eye and look at the world through an artist's eye. Notice the shapes between the branches of a tree, the shadow patterns cast across the road and the curve of a cat's tail as it saunters by. Sketch a spider web from memory and then find one in the garden and make a comparison. You'll be surprised at the details you've never noticed. Learn to see and the images will begin to flow from your mind, through your fingers and right onto the paper. Now relax, think positively and begin—the smile of success awaits you.

# Drawing Freehand

Study the subject to be drawn with an artist's eye. Break the form of the subject into small, easy to draw shapes. Note how each shape ties into its surroundings.

Begin by setting down simple geometric shapes in pencil.

Keep your pencil work light and erasable.

(1.)

(2.)

Use vertical and horizontal comparison lines to help you spot mistakes, then refine and correct the pencil drawing.

Pencil in details and shadows.

Note high-light areas.

(3.)

Overlay the pencil with pen and ink.

Maintain shadows and high-lights

(4.)

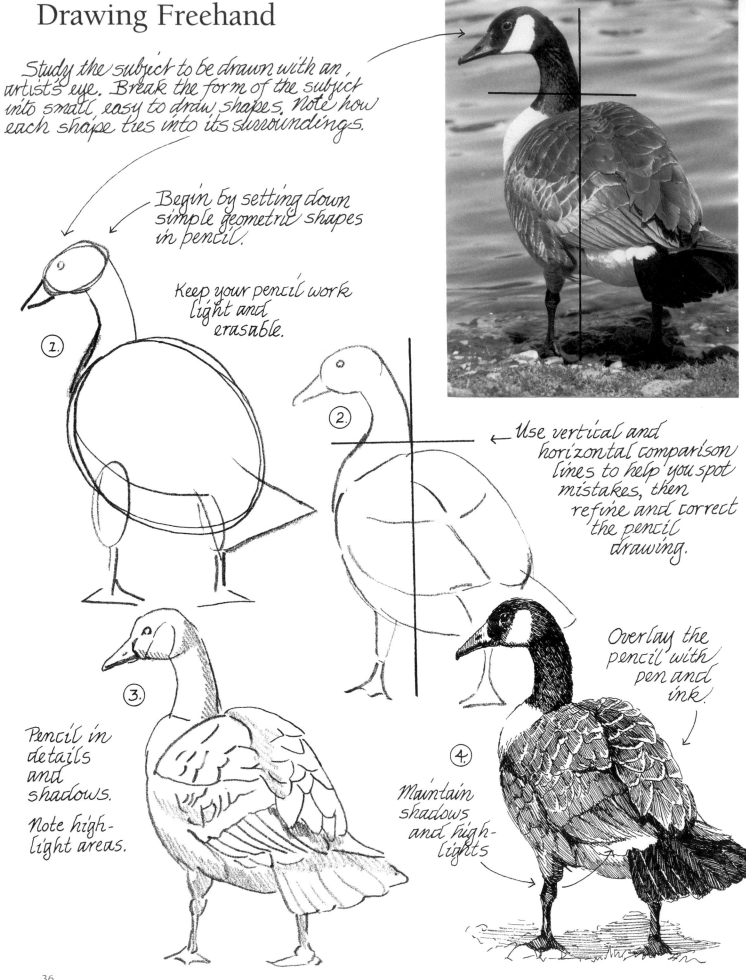

36

Quick sketches are useful for outdoor drawing, where time is limited, weather and shadows change and animal subjects are apt to wander away.

Work directly in pen & ink using rapid, loose, scribbly strokes. Correct mistakes by overlaying them with new lines.

Use geometric shapes as building blocks.

Keep line work simple.

Quick sketches are usually less than accurate, but appealing in their simplicity and spontaneity.

Your own hand makes a good subject for practicing quick sketches. Concentrate on "seeing" and setting down the various shapes. Then add scribbly shadows.

Don't worry about stray lines. They add to the sketchy look.

Value contrasts will help complicated subjects maintain definition, in a loosely rendered sketch.

Avoid overworking a sketch into a mono-tone scribbly jumble. Know when to stop!

# Sketching Trees

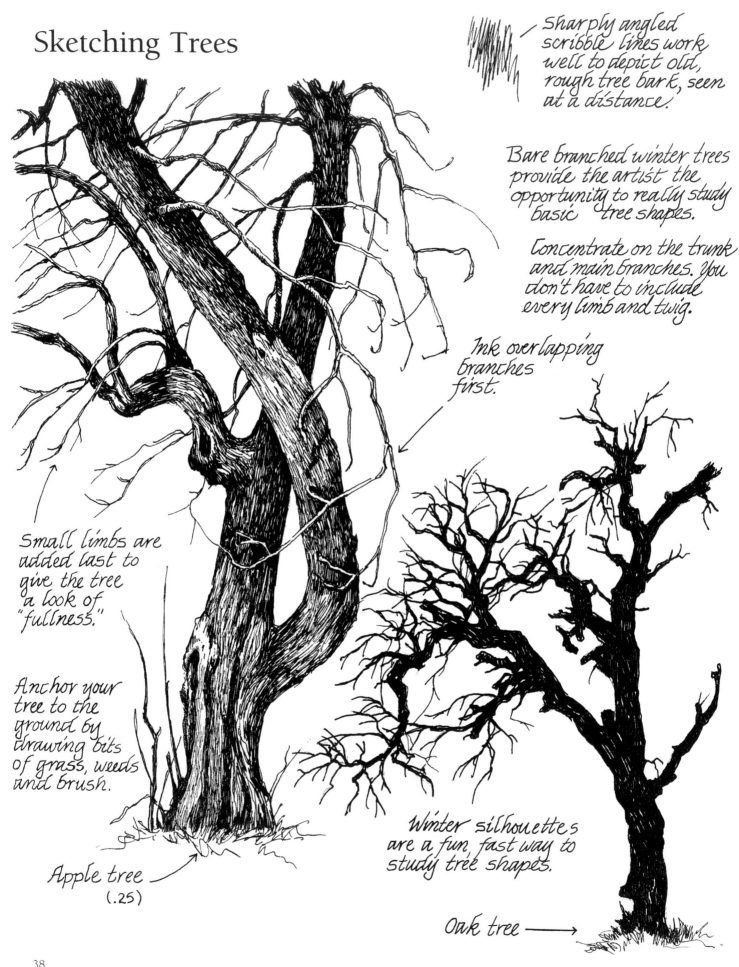

Sharply angled scribble lines work well to depict old, rough tree bark, seen at a distance.

Bare branched winter trees provide the artist the opportunity to really study basic tree shapes.

Concentrate on the trunk and main branches. You don't have to include every limb and twig.

Ink overlapping branches first.

Small limbs are added last to give the tree a look of "fullness."

Anchor your tree to the ground by drawing bits of grass, weeds and brush.

Apple tree (.25)

Winter silhouettes are a fun, fast way to study tree shapes.

Oak tree →

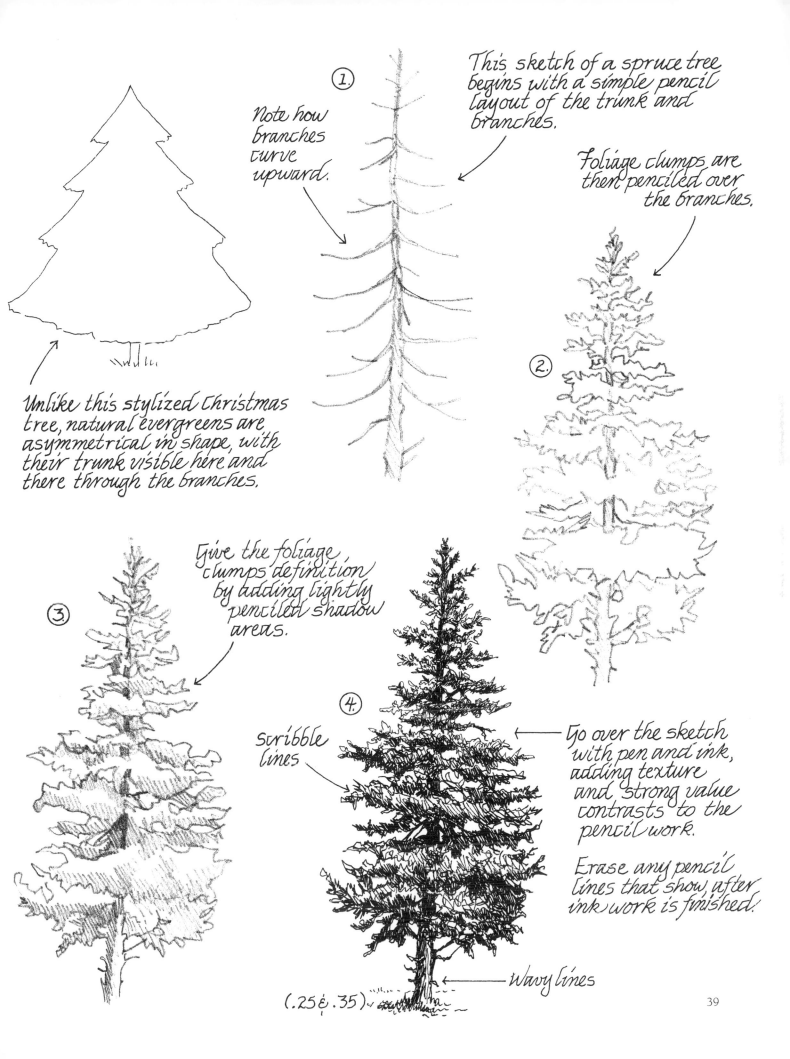

① This sketch of a spruce tree begins with a simple pencil layout of the trunk and branches.

Note how branches curve upward.

Foliage clumps are then penciled over the branches.

Unlike this stylized Christmas tree, natural evergreens are asymmetrical in shape, with their trunk visible here and there through the branches.

②

③ Give the foliage clumps definition by adding lightly penciled shadow areas.

④

scribble lines

Go over the sketch with pen and ink, adding texture and strong value contrasts to the pencil work.

Erase any pencil lines that show, after ink work is finished.

Wavy lines

(.25 & .35)

39

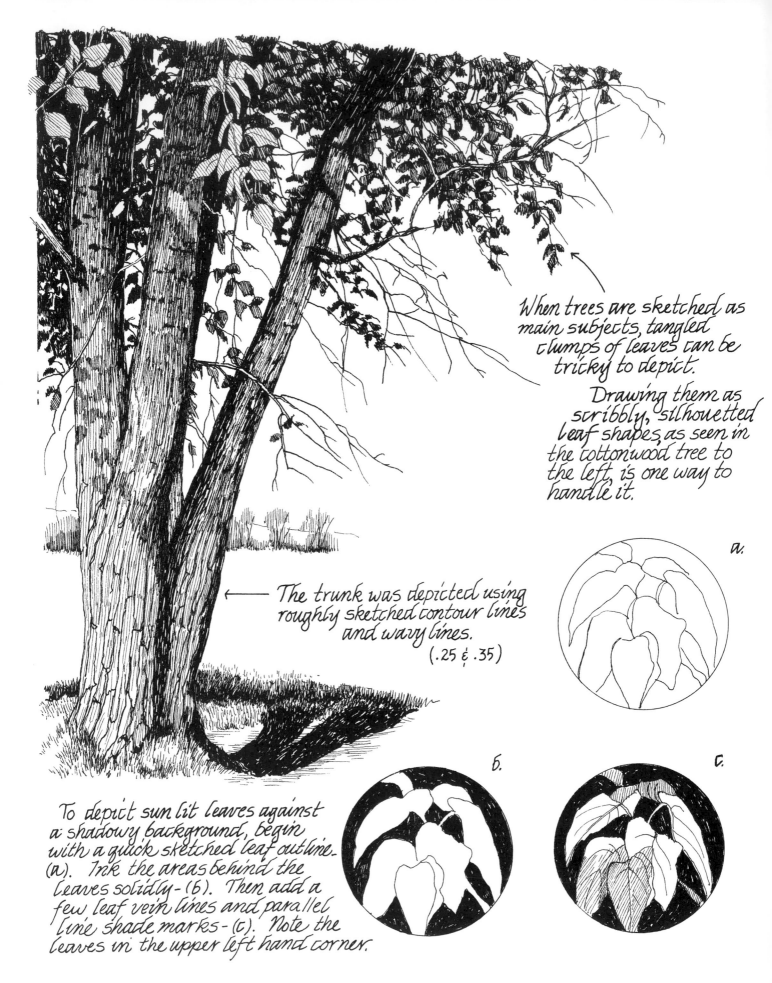

When trees are sketched as main subjects, tangled clumps of leaves can be tricky to depict.

Drawing them as scribbly, silhouetted leaf shapes, as seen in the cottonwood tree to the left, is one way to handle it.

The trunk was depicted using roughly sketched contour lines and wavy lines.
(.25 & .35)

a.

b.

c.

To depict sun lit leaves against a shadowy background, begin with a quick sketched leaf outline - (a). Ink the areas behind the leaves solidly - (b). Then add a few leaf vein lines and parallel line shade marks - (c). Note the leaves in the upper left hand corner.

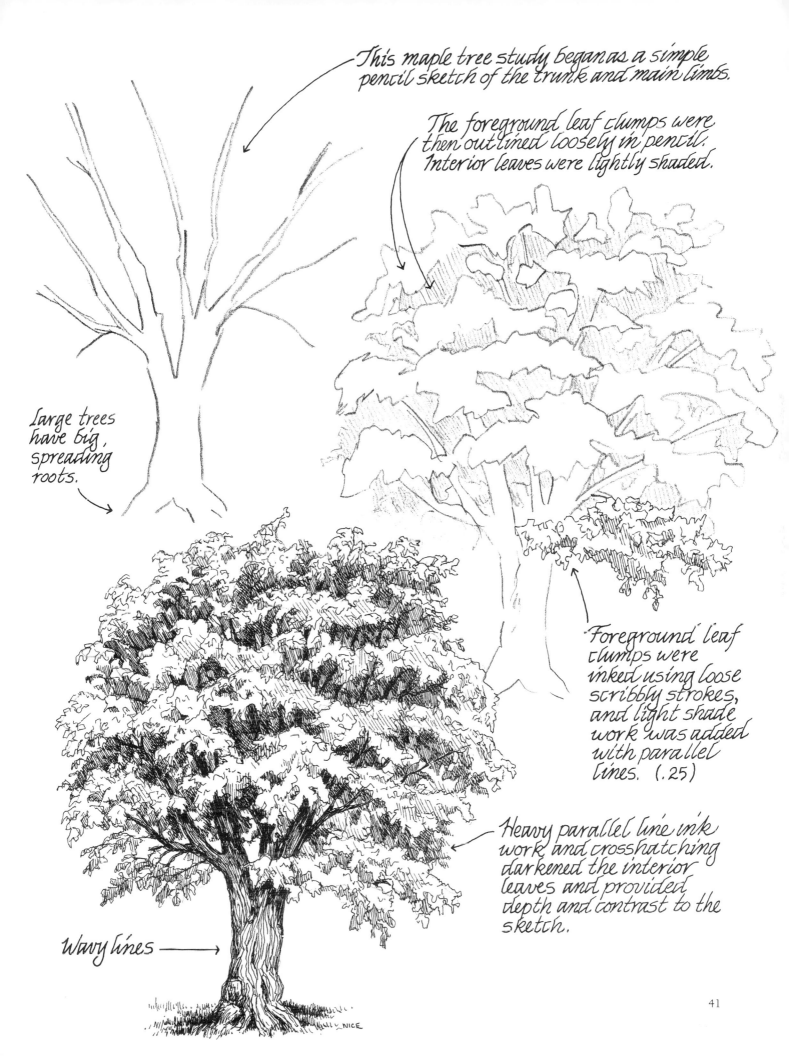

This maple tree study began as a simple pencil sketch of the trunk and main limbs.

The foreground leaf clumps were then outlined loosely in pencil. Interior leaves were lightly shaded.

large trees have big, spreading roots.

Foreground leaf clumps were inked using loose scribbly strokes, and light shade work was added with parallel lines. (.25)

Heavy parallel line ink work and crosshatching darkened the interior leaves and provided depth and contrast to the sketch.

Wavy lines ———→

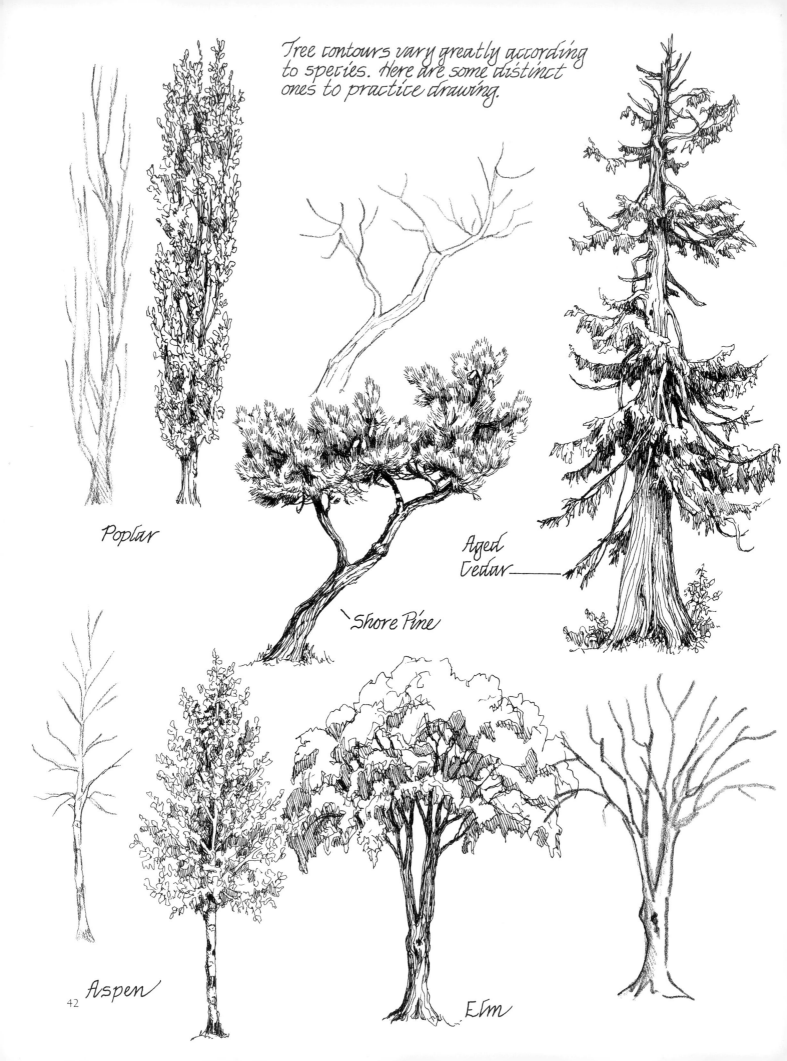

Tree contours vary greatly according to species. Here are some distinct ones to practice drawing.

Poplar

Shore Pine

Aged Cedar

Aspen

42

Elm

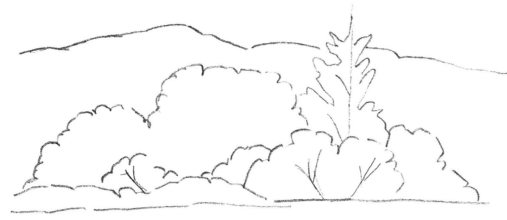

Background trees and distant forests should complement but not compete with foreground subjects. Keep them simple.

Preliminary pencil sketch

Combinations of simple outlines, scribble strokes and parallel lines work well to suggest distant tree groupings.

Use texture and value contrast to suggest shape.

The farther away a subject is the simpler the lines representing it should be.

Parallel lines with a broken outline along the upper edge... simple and effective!

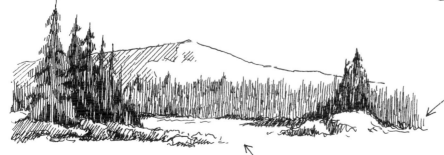

Use plain parallel lines to depict forests seen at an extreme distance.

Open areas provide an interesting diversity.

43

# Sketching Leaves

Leaf textures are so diverse that all seven pen and ink strokes can be used in their depiction.

Smooth leaves can best be represented using parallel lines or slightly curved contour lines.

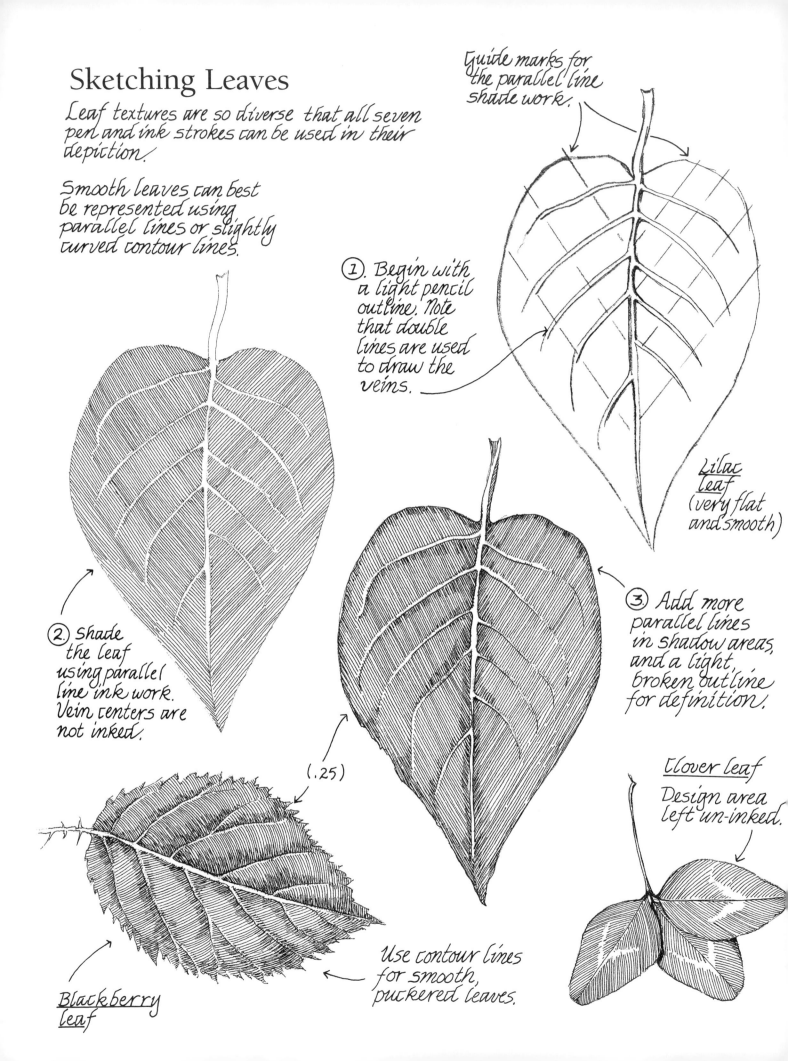

Guide marks for the parallel line shade work.

① Begin with a light pencil outline. Note that double lines are used to draw the veins.

Lilac leaf (very flat and smooth)

② Shade the leaf using parallel line ink work. Vein centers are not inked.

(.25)

③ Add more parallel lines in shadow areas, and a light broken outline for definition.

Clover leaf
Design area left un-inked.

Blackberry leaf

Use contour lines for smooth, puckered leaves.

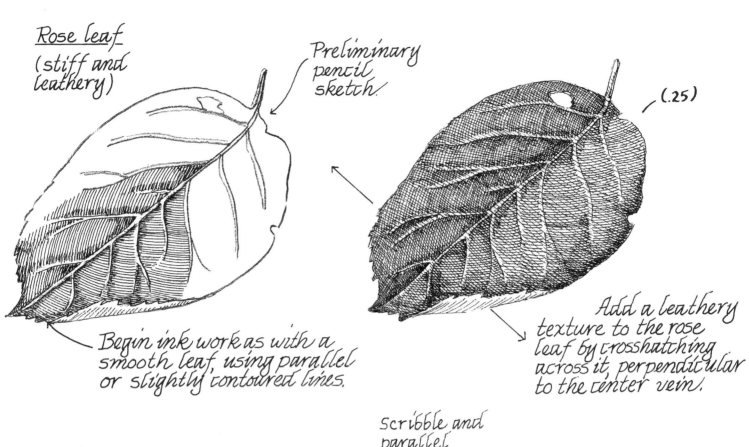

Rose leaf
(stiff and leathery)

Preliminary pencil sketch.

(.25)

Begin ink work as with a smooth leaf, using parallel or slightly contoured lines.

Add a leathery texture to the rose leaf by crosshatching across it, perpendicular to the center vein.

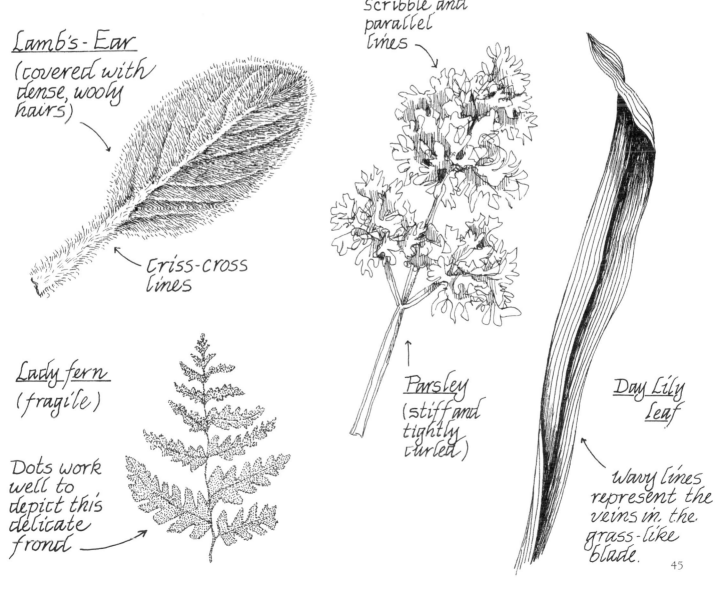

scribble and parallel lines

Lamb's-Ear
(covered with dense, wooly hairs)

Criss-cross lines

Lady fern
(fragile)

Dots work well to depict this delicate frond

Parsley
(stiff and tightly curled)

Day Lily Leaf

Wavy lines represent the veins in the grass-like blade.

45

# Sketching Florals

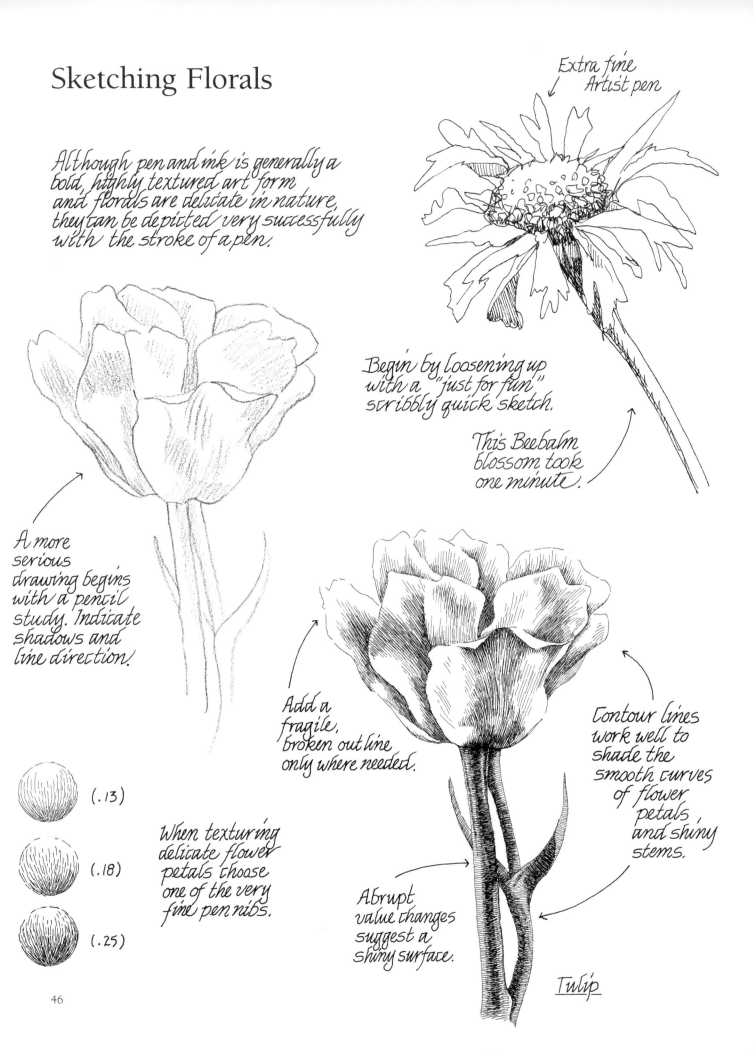

Although pen and ink is generally a bold, highly textured art form and florals are delicate in nature, they can be depicted very successfully with the stroke of a pen.

Extra fine Artist pen

Begin by loosening up with a "just for fun" scribbly quick sketch.

This Beebalm blossom took one minute.

A more serious drawing begins with a pencil study. Indicate shadows and line direction.

(.13)

(.18)

(.25)

When texturing delicate flower petals choose one of the very fine pen nibs.

Add a fragile, broken out line only where needed.

Abrupt value changes suggest a shiny surface.

Contour lines work well to shade the smooth curves of flower petals, and shiny stems.

Tulip

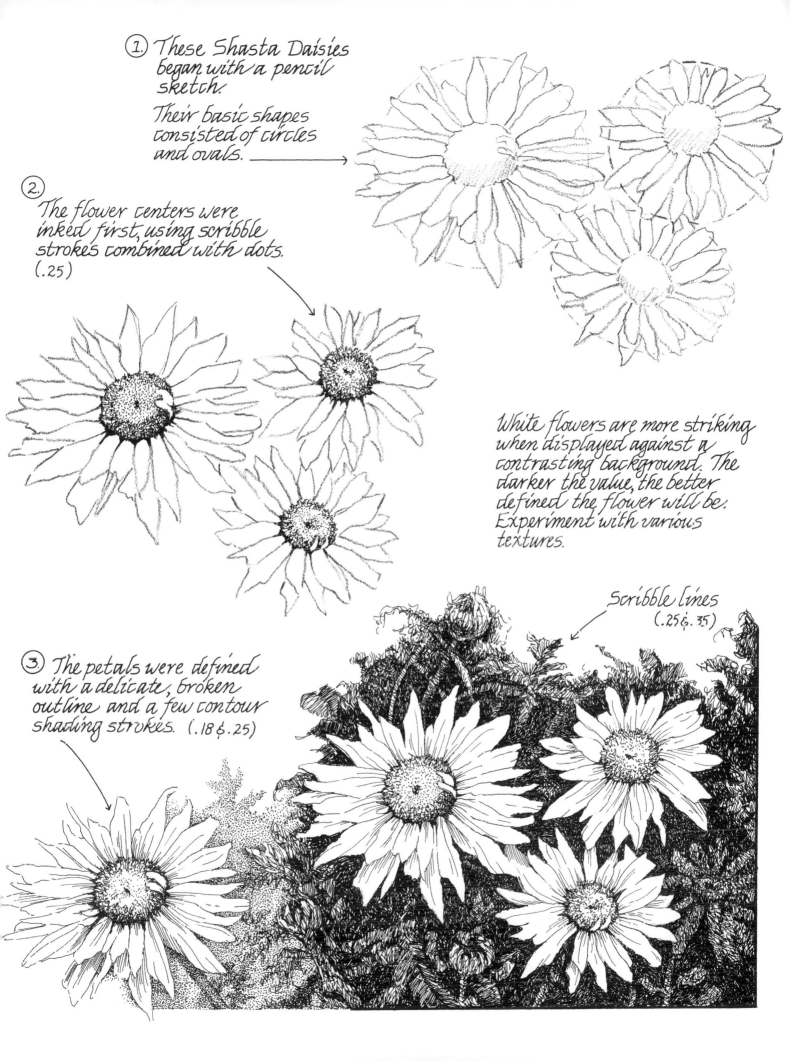

1. These Shasta Daisies began with a pencil sketch.

Their basic shapes consisted of circles and ovals. ⟶

2. The flower centers were inked first, using scribble strokes combined with dots. (.25)

White flowers are more striking when displayed against a contrasting background. The darker the value, the better defined the flower will be. Experiment with various textures.

Scribble lines (.25 & .35)

3. The petals were defined with a delicate, broken outline and a few contour shading strokes. (.18 & .25)

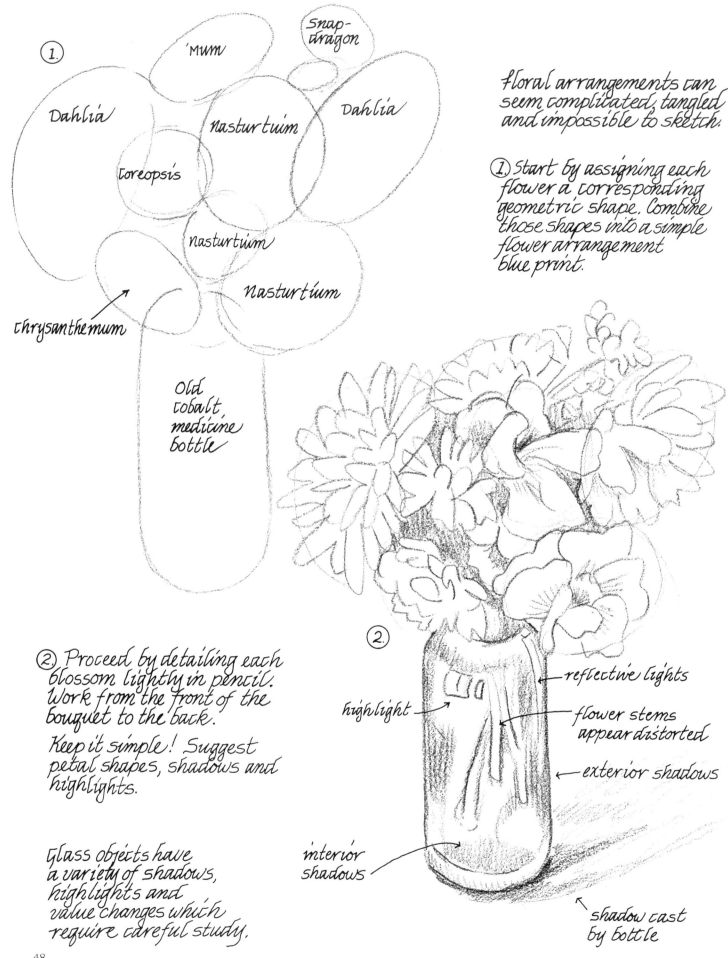

1.

'mum

Snap-dragon

Dahlia

Nasturtuim

Dahlia

Coreopsis

nasturtium

Nasturtium

chrysanthemum

Old cobalt medicine bottle

Floral arrangements can seem complicated, tangled and impossible to sketch.

1. Start by assigning each flower a corresponding geometric shape. Combine those shapes into a simple flower arrangement blue print.

2.

reflective lights

highlight

flower stems appear distorted

exterior shadows

interior shadows

shadow cast by bottle

2. Proceed by detailing each blossom lightly in pencil. Work from the front of the bouquet to the back.

Keep it simple! Suggest petal shapes, shadows and highlights.

Glass objects have a variety of shadows, highlights and value changes which require careful study.

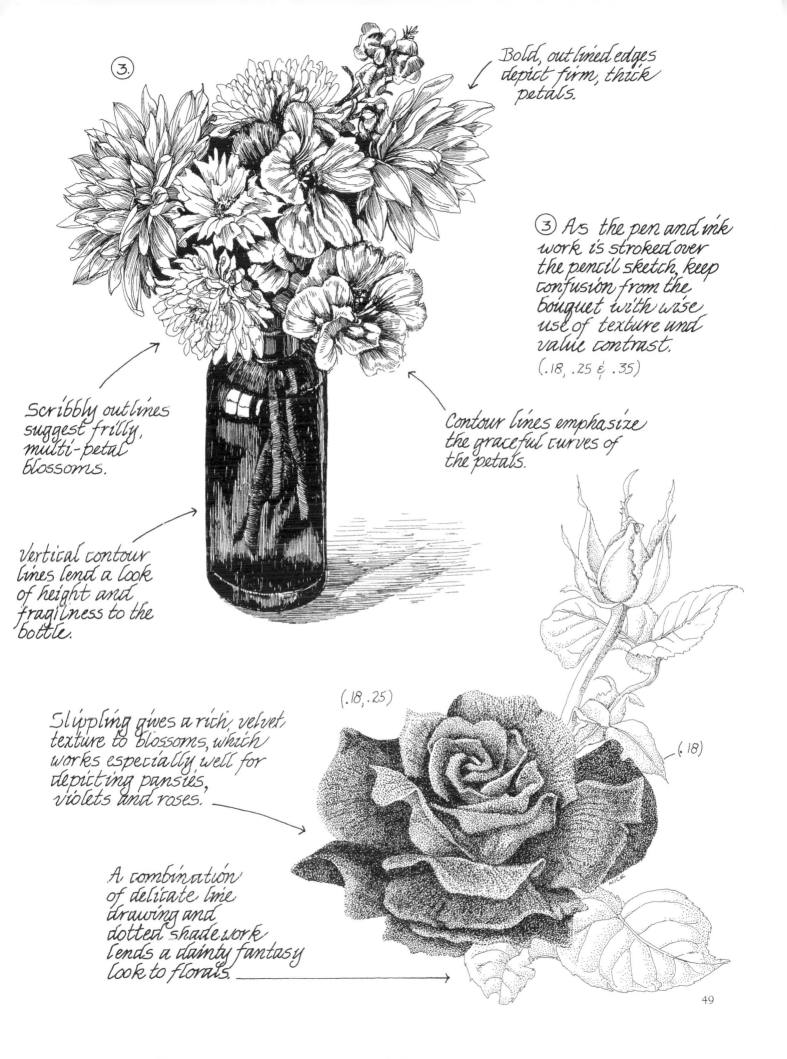

③.

Bold, outlined edges
depict firm, thick
petals.

③ As the pen and ink
work is stroked over
the pencil sketch, keep
confusion from the
bouquet with wise
use of texture and
value contrast.
(.18, .25 & .35)

Scribbly outlines
suggest frilly,
multi-petal
blossoms.

Contour lines emphasize
the graceful curves of
the petals.

Vertical contour
lines lend a look
of height and
fragileness to the
bottle.

(.18, .25)

(.18)

Stippling gives a rich, velvet
texture to blossoms, which
works especially well for
depicting pansies,
violets and roses.

A combination
of delicate line
drawing and
dotted shade work
lends a dainty fantasy
look to florals.

# Depicting Grass and Weeds

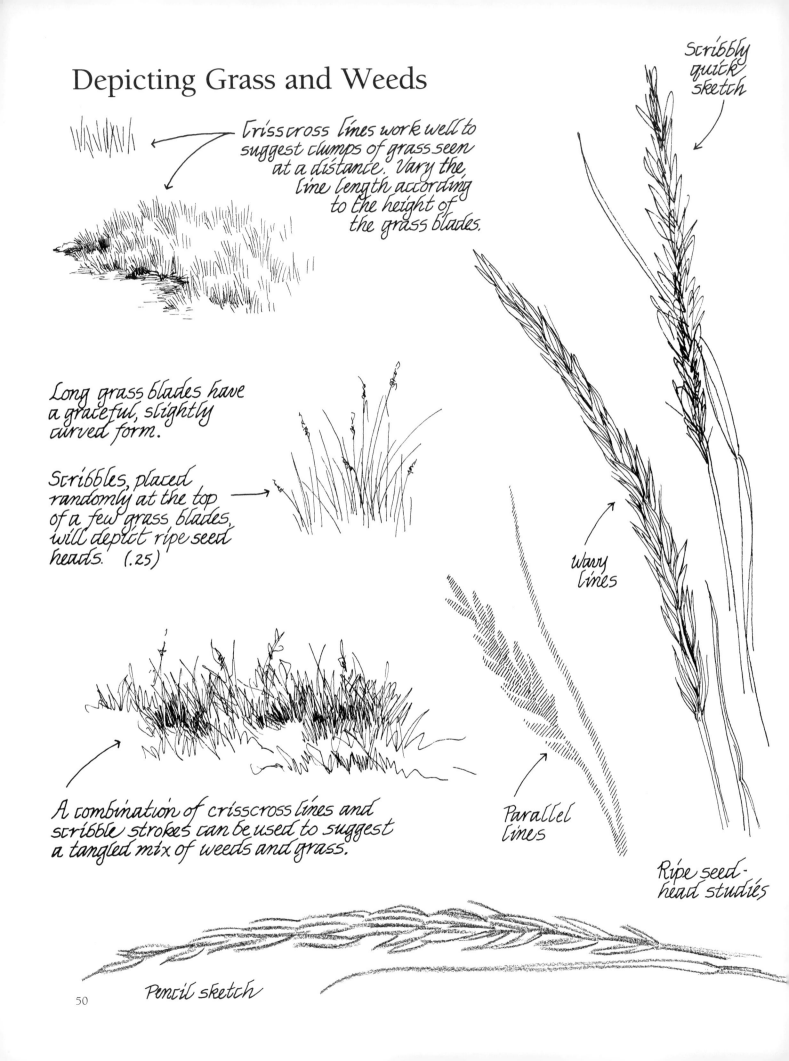

Crisscross lines work well to suggest clumps of grass seen at a distance. Vary the line length according to the height of the grass blades.

scribbly quick sketch

Long grass blades have a graceful, slightly curved form.

Scribbles, placed randomly at the top of a few grass blades, will depict ripe seed heads. (.25)

wavy lines

A combination of crisscross lines and scribble strokes can be used to suggest a tangled mix of weeds and grass.

Parallel lines

Ripe seed-head studies

Pencil sketch

50

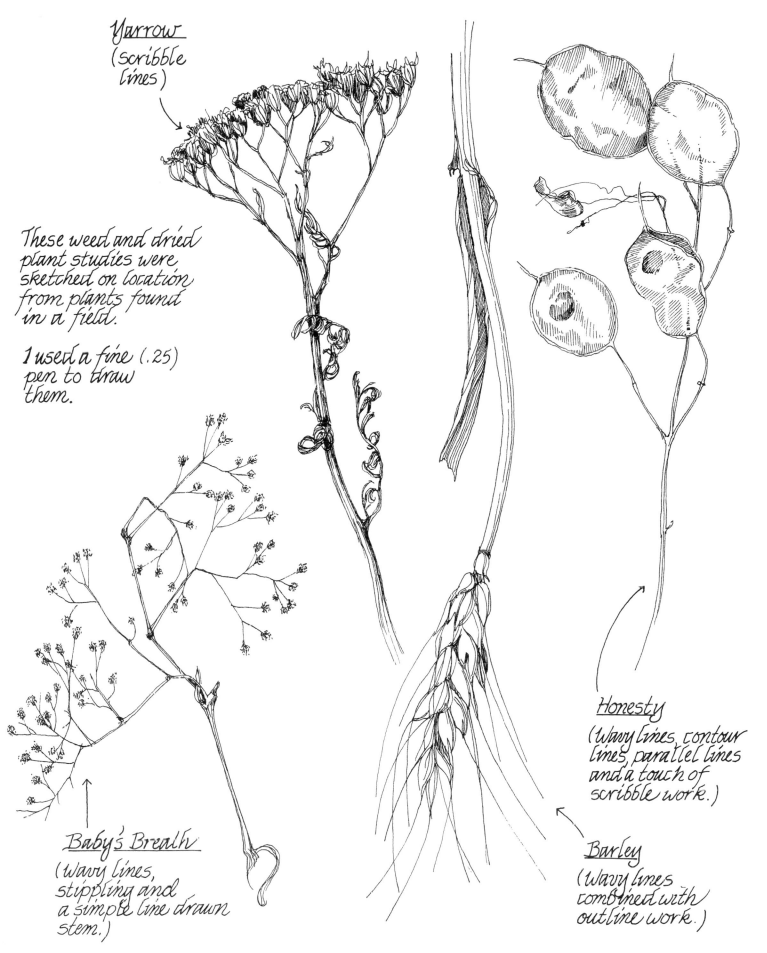

Yarrow
(scribble
lines)

These weed and dried
plant studies were
sketched on location
from plants found
in a field.

I used a fine (.25)
pen to draw
them.

Honesty
(Wavy lines, contour
lines, parallel lines
and a touch of
scribble work.)

Barley
(Wavy lines
combined with
outline work.)

Baby's Breath
(Wavy lines,
stippling and
a simple line drawn
stem.)

# Fruits and Vegetables

When sketching smooth, satin finished fruits such as apples, pay special attention to the placement of highlights, reflected lights and shadows.

Study the subject carefully and search out those value changes!

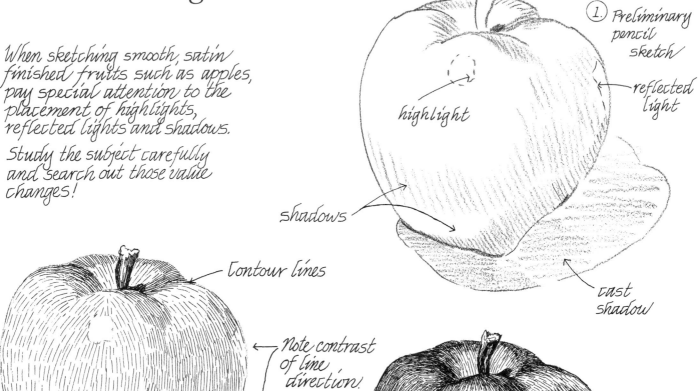

① Preliminary pencil sketch

reflected light

highlight

shadows

cast shadow

Contour lines

Note contrast of line direction.

Parallel lines

② Begin pen and ink work. Establish texture and line direction while maintaining highlight and shadow areas.

(.25)

③ Deepen shadows. For a satin sheen appearance, blend areas of value change smoothly together at the edges. Add outlines only where needed for definition.

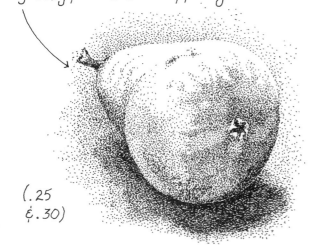

Gritty pear skin - stippling

(.25 & .30)

hairy skinned kiwi - crisscross line

(.18 & .25)

Squash, gourds and Indian
corn will provide wonderful
shapes and textures for a
harvest still life.

crisp, dried corn
husks - wavy lines
(.25)

smooth-skinned
acorn squash -
contour lines
(.25)

Wart-skinned,
crooked neck
squash -
contour lines
(.25)

Crosshatched shadows
provide additional
textural contrast.
(.35)

Highlight spots are
important when
depicting shiny kernels
of Indian corn.

# Sketching Inanimate Objects

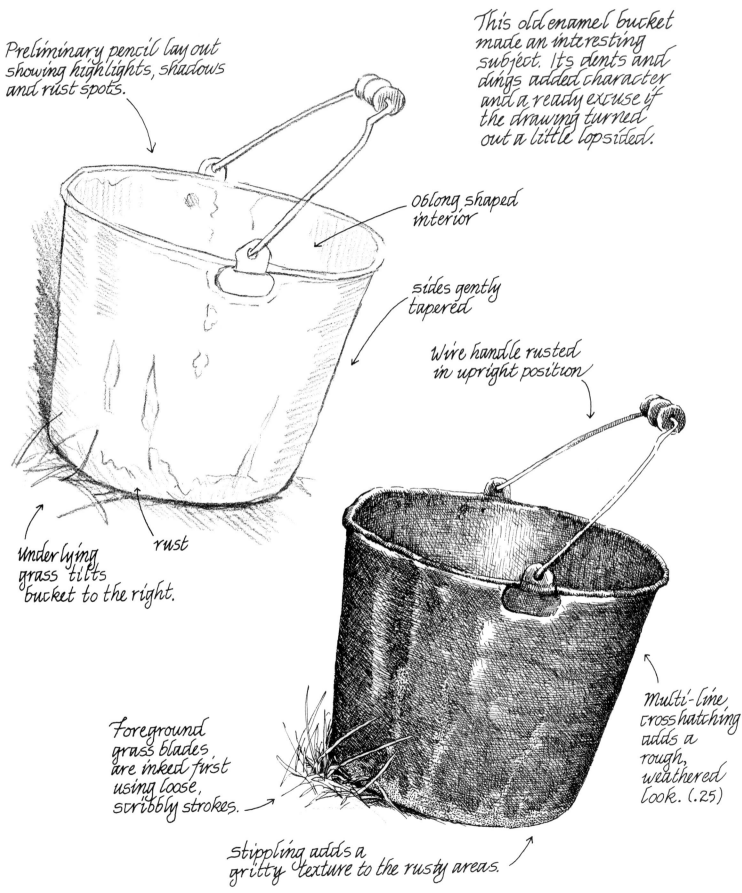

Preliminary pencil layout showing highlights, shadows and rust spots.

This old enamel bucket made an interesting subject. Its dents and dings added character and a ready excuse if the drawing turned out a little lopsided.

Oblong shaped interior

sides gently tapered

Wire handle rusted in upright position

rust

Underlying grass tilts bucket to the right.

Foreground grass blades are inked first using loose, scribbly strokes.

Multi-line crosshatching adds a rough, weathered look. (.25)

stippling adds a gritty texture to the rusty areas.

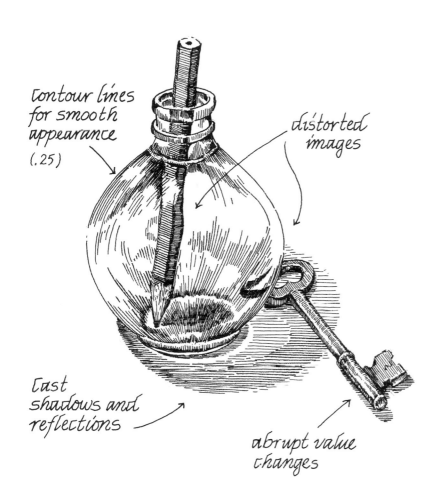

Contour lines for smooth appearance (.25)

distorted images

Cast shadows and reflections

abrupt value changes

Polished surfaces have an abundance of white highlights and reflected tones. Value changes are often abrupt, representing glare, sparkle and mirror-like reflections.

When depicting clear glass objects, the artist must also consider interior shapes, shadows and reflections, which may appear distorted.

Glass objects cast reflected lights as well as shadows.

Polished shell surface - smooth & reflective

Glazed bean pot - highly reflective

Rough, grainy shell surface - wavy lines & no reflections

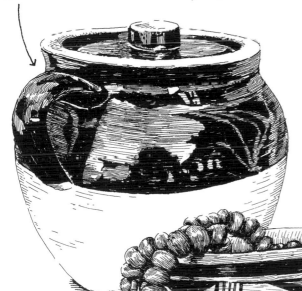

(.18, .25 & .35)

Glazed pottery can be highly reflective, readily picking up distorted images and a lot of color (value) changes.

Unglazed pottery has subtle value changes and little or no white highlight spots.

# Sketching Rocks

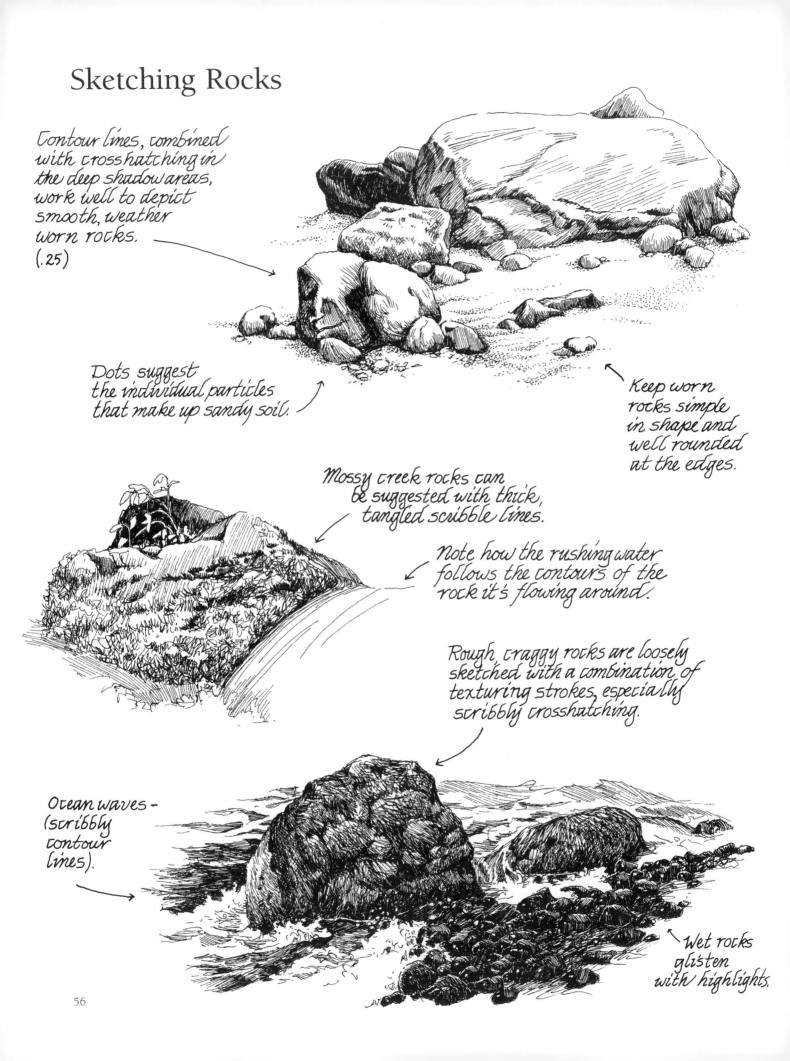

Contour lines, combined with crosshatching in the deep shadow areas, work well to depict smooth, weather worn rocks. (.25)

Dots suggest the individual particles that make up sandy soil.

Keep worn rocks simple in shape and well rounded at the edges.

Mossy creek rocks can be suggested with thick, tangled scribble lines.

Note how the rushing water follows the contours of the rock it's flowing around.

Rough, craggy rocks are loosely sketched with a combination of texturing strokes, especially scribbly crosshatching.

Ocean waves — (scribbly contour lines).

Wet rocks glisten with highlights.

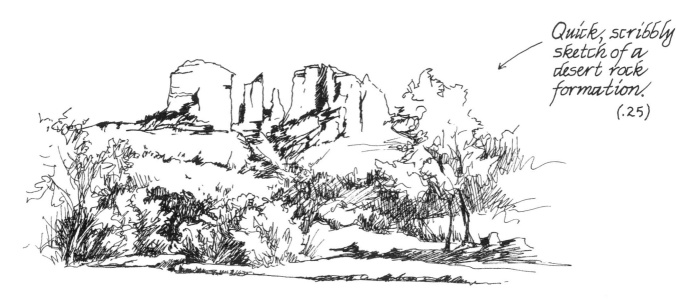

Quick, scribbly
sketch of a
desert rock
formation.
(.25)

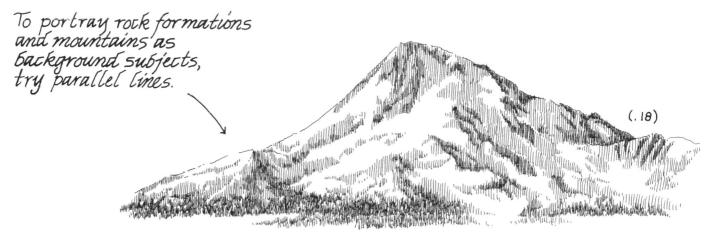

To portray rock formations
and mountains as
background subjects,
try parallel lines.

(.18)

Since rocks come in all sizes, adding compurative
subjects to the sketch can help establish just how
big the rocks are.

Draw the essence of a
complicated rock formation—
not every rock. Scribble
lines can help simplify the
job.

(.18, .25 & .30)

57

# Depicting Water

Pools of still water cast reflections like a mirror. These reversed reflections seem to stretch down into the depths of the water and can be represented with vertical parallel lines. Add a few horizontal water surface lines.

(.18, .25 & .35)

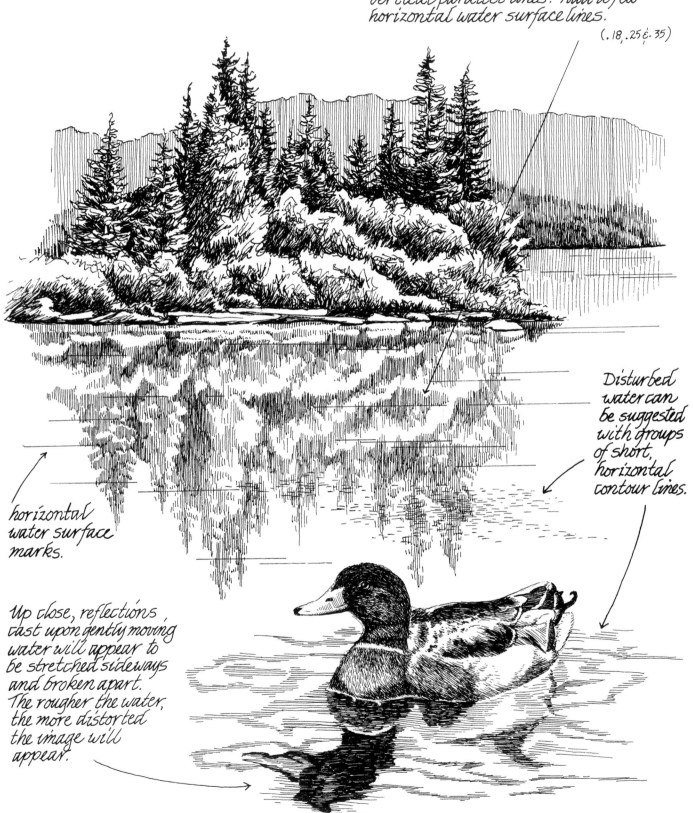

Disturbed water can be suggested with groups of short, horizontal contour lines.

horizontal water surface marks.

Up close, reflections cast upon gently moving water will appear to be stretched sideways and broken apart. The rougher the water, the more distorted the image will appear.

58

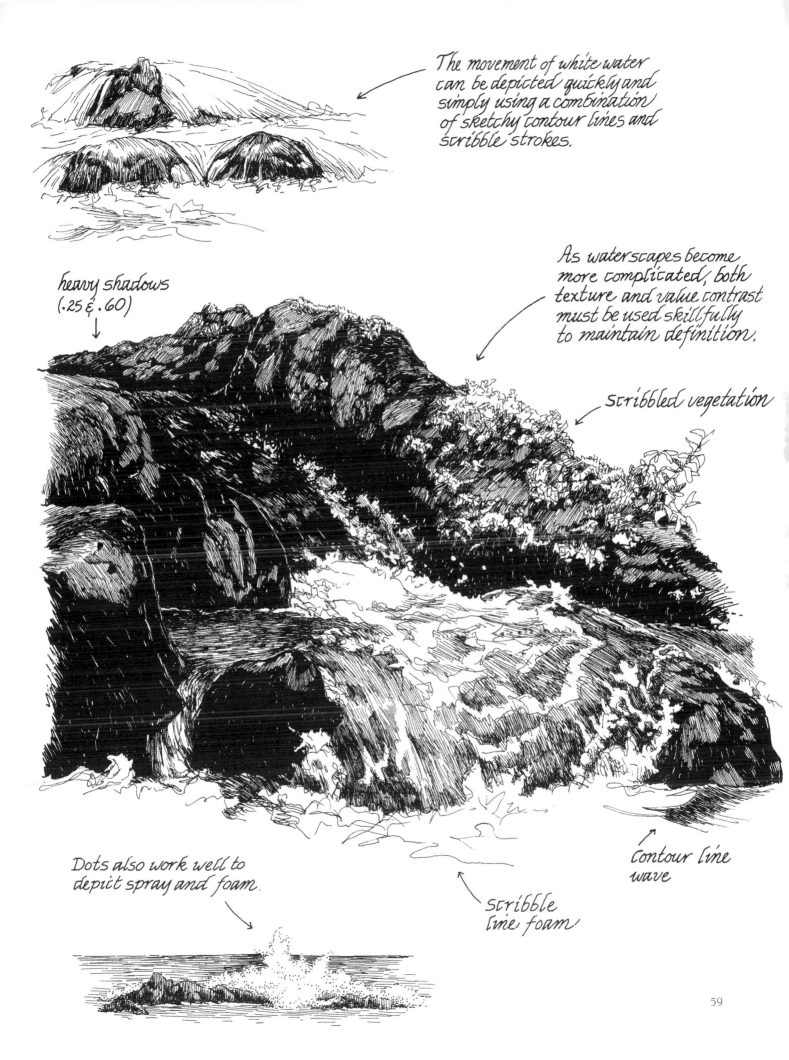

The movement of white water can be depicted quickly and simply using a combination of sketchy contour lines and scribble strokes.

As waterscapes become more complicated, both texture and value contrast must be used skillfully to maintain definition.

heavy shadows (.25 & .60)

scribbled vegetation

Dots also work well to depict spray and foam.

scribble line foam

Contour line wave

59

# Sketching the Sky

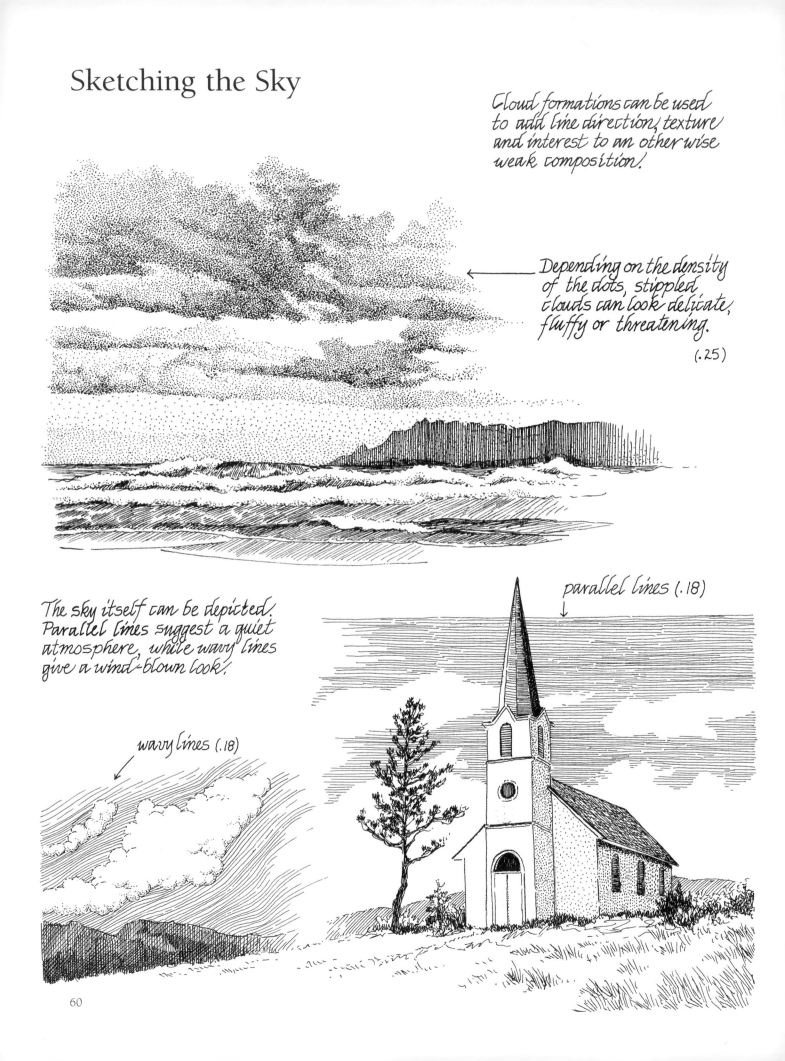

Cloud formations can be used to add line direction, texture and interest to an otherwise weak composition.

Depending on the density of the dots, stippled clouds can look delicate, fluffy or threatening.

(.25)

parallel lines (.18)

The sky itself can be depicted. Parallel lines suggest a quiet atmosphere, while wavy lines give a wind-blown look.

wavy lines (.18)

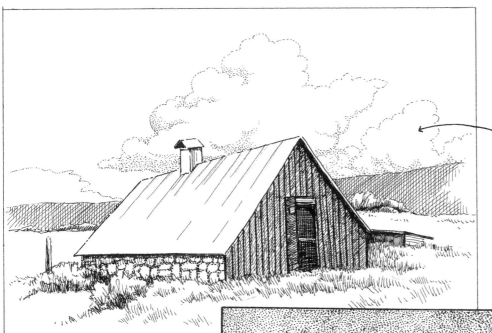

The appearance of the sky can help set the over all mood of a landscape.

This sky is bright, delicate and passive, creating a sunny mood.

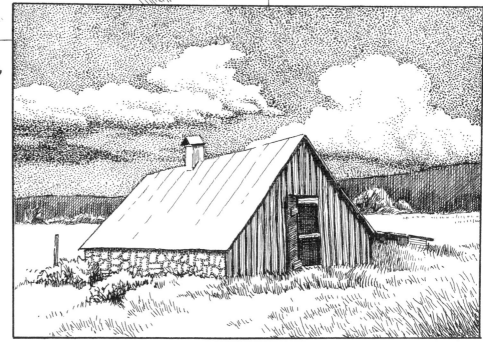

Here the textured and highly contrasted sky creates the feeling of drama.

The clouds are featured as an important part of the design.

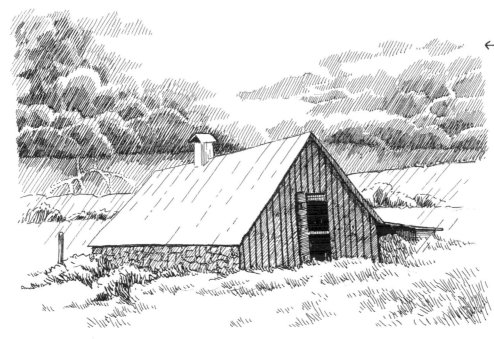

Parallel lines in the shape of thunder heads and rain squalls can portray the power and violence of a storm.

61

# Sketching Buildings in Perspective

Perspective is the technique of depicting dimensional objects on a flat surface. It's helpful to know a few simple principles about perspective before attempting landscapes with buildings.

Note: There is only one horizon line per drawing and everything in that drawing relates to it.

① The artist's horizon line is located at "eye level."

The viewer will look up to subjects above the eye level (a) and down upon those below (c). Eye-level subjects are viewed straight on (b).

vanishing point

horizon line (eye level)

These parallel lines converge off paper.

② Objects appear to grow smaller as they recede into the distance, disappearing altogether at the "vanishing point." There may be more than one vanishing point in a composition, each one located somewhere along the horizon line.

Use diagonal lines to determine the center of a rectangle seen in perspective. A vertical line through the center will provide an accurate ridge for the roof. The pitch of the roof is up to the artist, depending on how high the center ridge line is extended.

③ Lines that run parallel to each other like the roof line, foundation and horizontal window edges will appear to grow closer together, and if extended will converge on the horizon at a single vanishing point. Each side of the building viewed will have its own vanishing point.

If the parallel lines do not converge, the building is out of perspective.

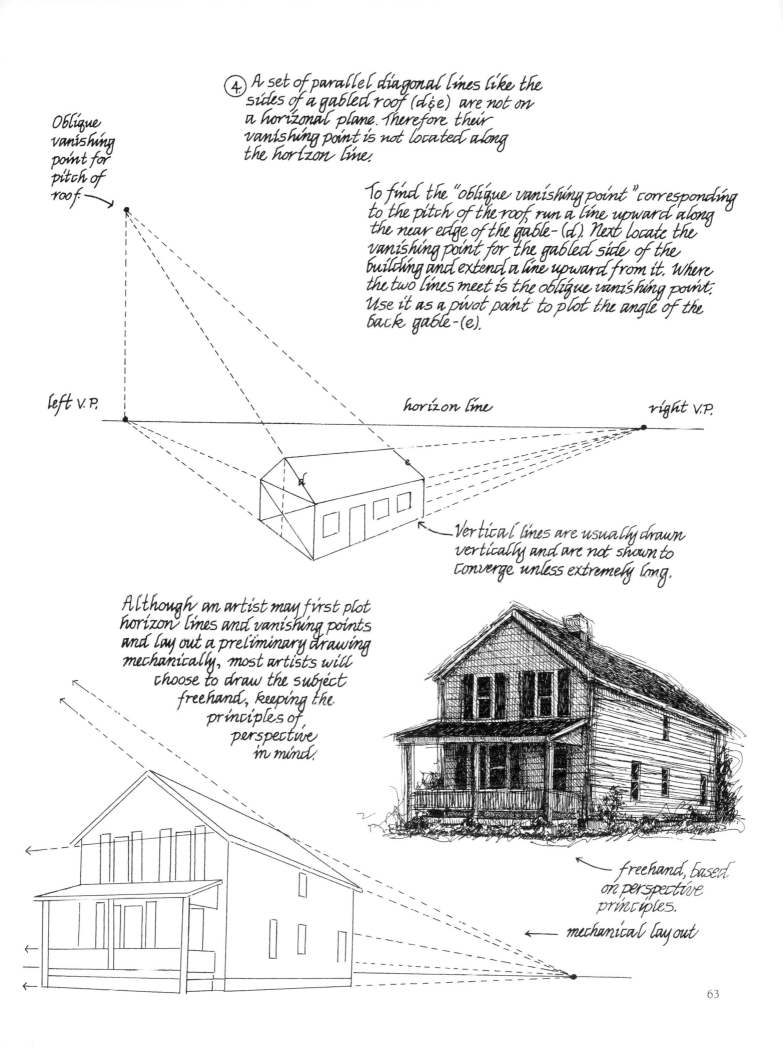

④ A set of parallel diagonal lines like the sides of a gabled roof (d&e) are not on a horizonal plane. Therefore their vanishing point is not located along the horizon line.

To find the "oblique vanishing point" corresponding to the pitch of the roof, run a line upward along the near edge of the gable- (d). Next locate the vanishing point for the gabled side of the building and extend a line upward from it. Where the two lines meet is the oblique vanishing point. Use it as a pivot point to plot the angle of the back gable-(e).

Oblique vanishing point for pitch of roof.

left V.P.

horizon line

right V.P.

Vertical lines are usually drawn vertically and are not shown to converge unless extremely long.

Although an artist may first plot horizon lines and vanishing points and lay out a preliminary drawing mechanically, most artists will choose to draw the subject freehand, keeping the principles of perspective in mind.

freehand, based on perspective principles.

mechanical lay out

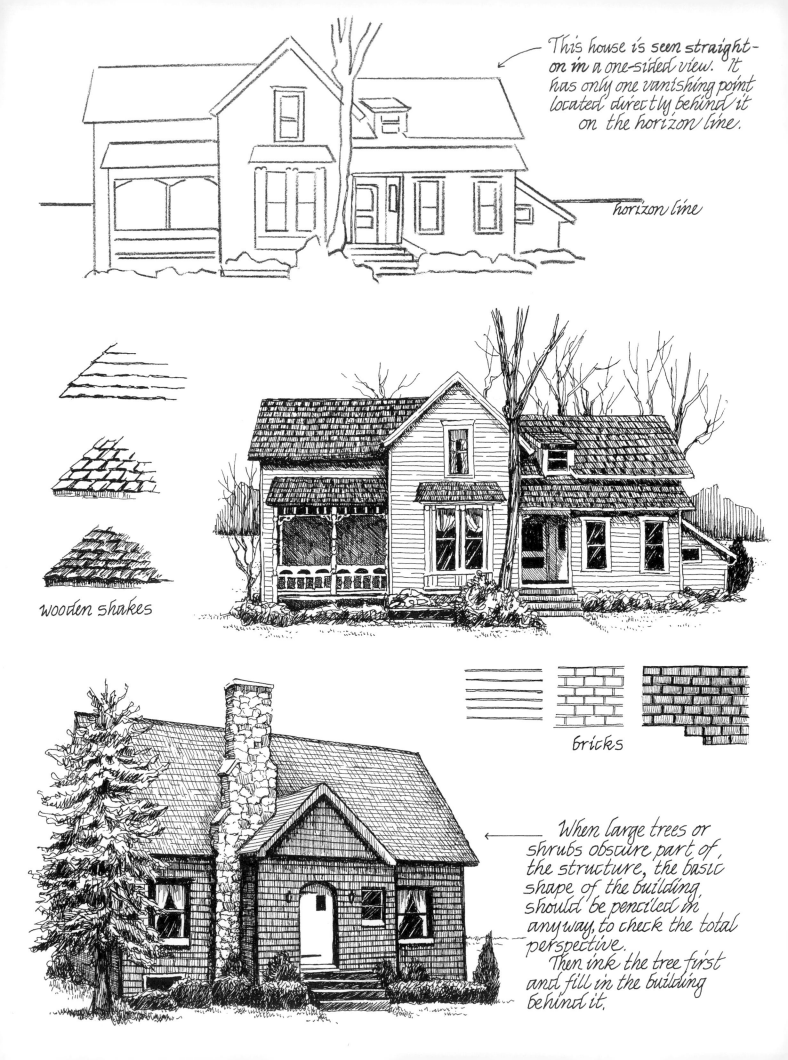

This house is seen straight-on in a one-sided view. It has only one vanishing point located directly behind it on the horizon line.

horizon line

wooden shakes

bricks

When large trees or shrubs obscure part of the structure, the basic shape of the building should be penciled in anyway, to check the total perspective.
Then ink the tree first and fill in the building behind it.

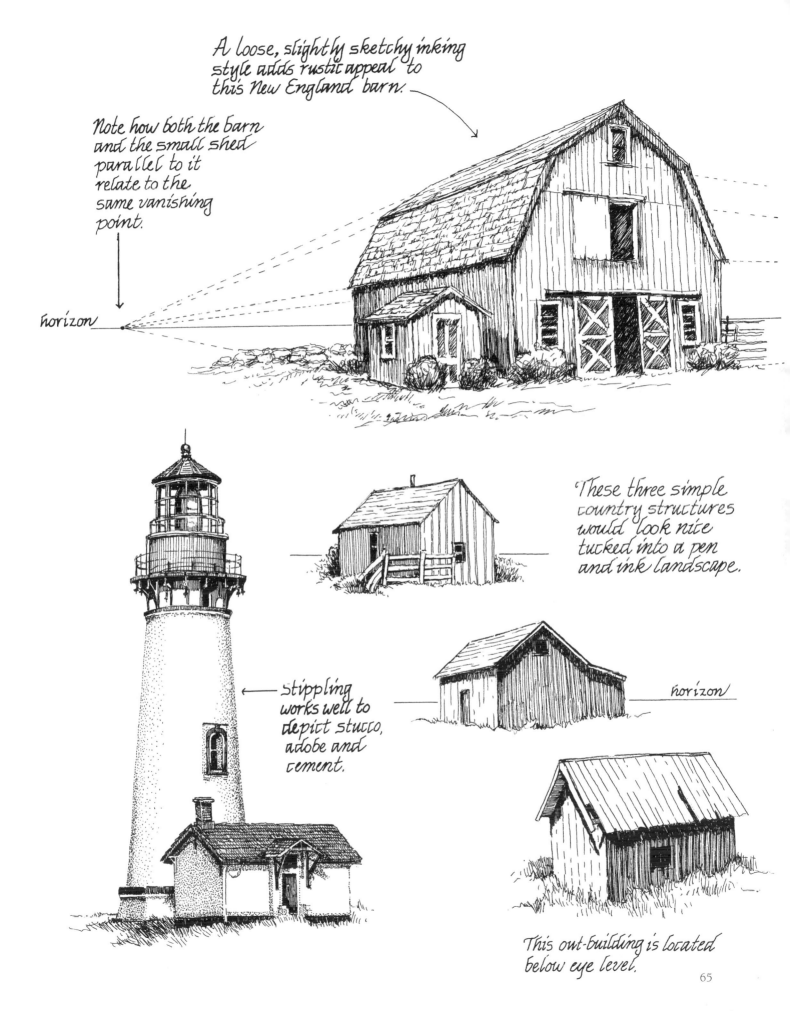

A loose, slightly sketchy inking style adds rustic appeal to this New England barn.

Note how both the barn and the small shed parallel to it relate to the same vanishing point.

horizon

These three simple country structures would look nice tucked into a pen and ink landscape.

horizon

stippling works well to depict stucco, adobe and cement.

This out-building is located below eye level.

# Sketching Animals

Begin your pen and ink animal drawings with a few scribbly quick sketches. This will allow you to relax, have fun and at the same time get a feel for how the animal is put together. Work from both photos and live models.

shoulder

rib cage

rump

Side views are the easiest figures to draw.

(.25)

Start by drawing a large oval for the rib cage and belly. Add the oval shapes that represent the shoulder and rump. These will change position with the action of the animal.

Now add the head, neck, and legs to the body using geometric building blocks.

Make changes and corrections as you work. They will show, but remember its a study!

Finish by tying the figure together, adding scribbly shadows for dimension, and sketching in important details like eyes, tails, etc.

Don't forget cast shadows.

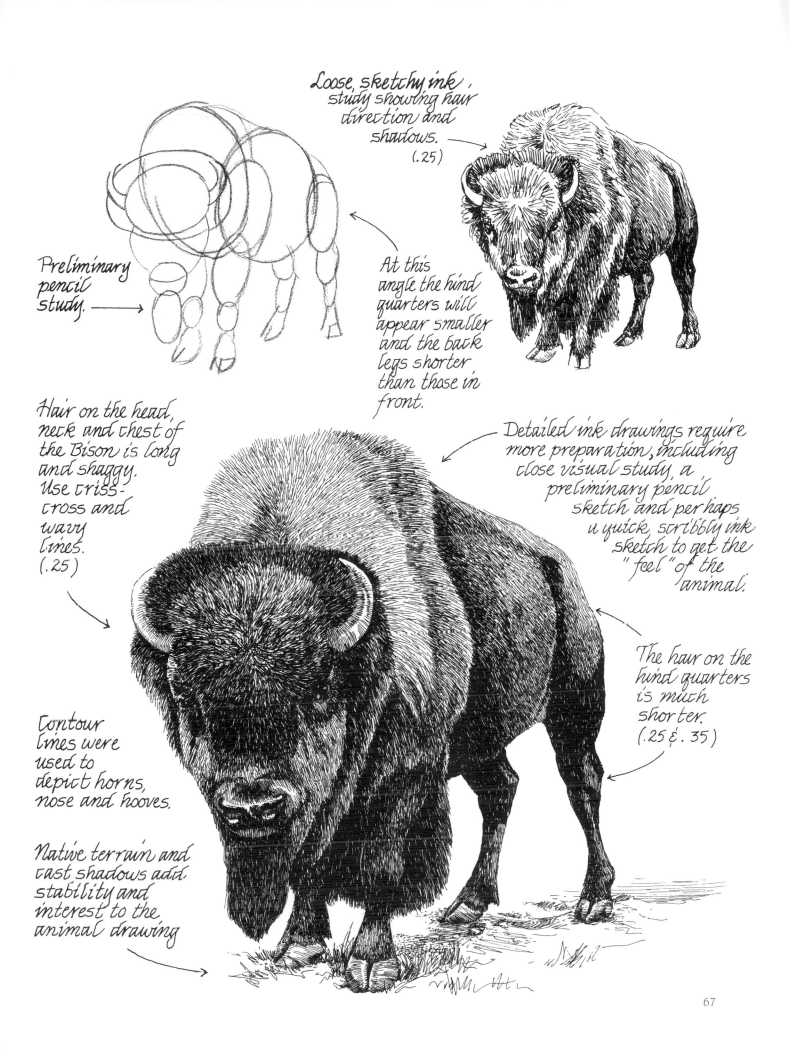

Loose, sketchy ink study showing hair direction and shadows. (.25)

Preliminary pencil study.

At this angle the hind quarters will appear smaller and the back legs shorter than those in front.

Hair on the head, neck and chest of the Bison is long and shaggy. Use criss-cross and wavy lines. (.25)

Detailed ink drawings require more preparation, including close visual study, a preliminary pencil sketch and perhaps a quick, scribbly ink sketch to get the "feel" of the animal.

The hair on the hind quarters is much shorter. (.25 & .35)

Contour lines were used to depict horns, nose and hooves.

Native terrain and cast shadows add stability and interest to the animal drawing

## criss cross hair

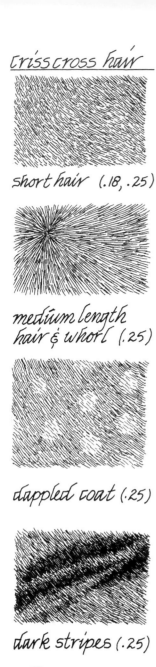

short hair   (.18, .25)

medium length
hair & whorl (.25)

dappled coat (.25)

dark stripes (.25)

black spots on white
(.25, .35)

multicolored coat
(.25, .35)

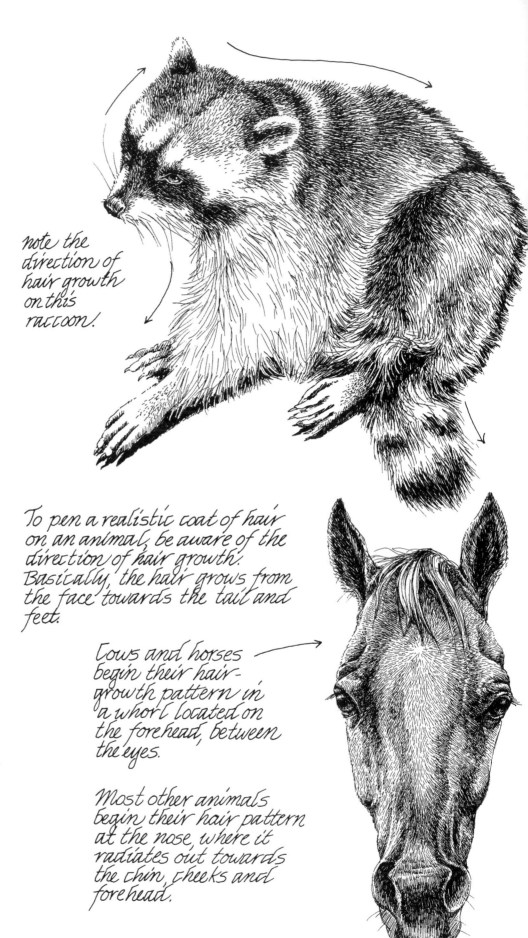

note the
direction of
hair growth
on this
raccoon.

To pen a realistic coat of hair
on an animal, be aware of the
direction of hair growth.
Basically, the hair grows from
the face towards the tail and
feet.

Cows and horses
begin their hair-
growth pattern in
a whorl located on
the forehead, between
the eyes.

Most other animals
begin their hair pattern
at the nose, where it
radiates out towards
the chin, cheeks and
forehead.

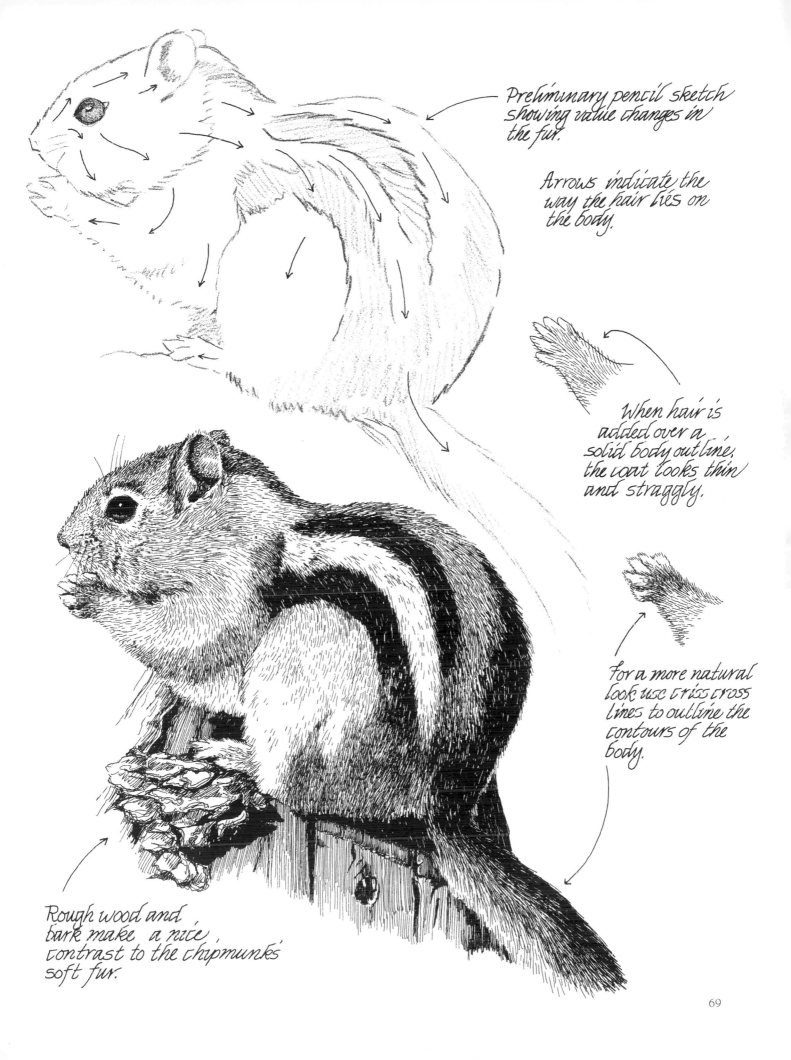

Preliminary pencil sketch showing value changes in the fur.

Arrows indicate the way the hair lies on the body.

When hair is added over a solid body outline, the coat looks thin and straggly.

For a more natural look use criss cross lines to outline the contours of the body.

Rough wood and bark make a nice contrast to the chipmunk's soft fur.

pencil study

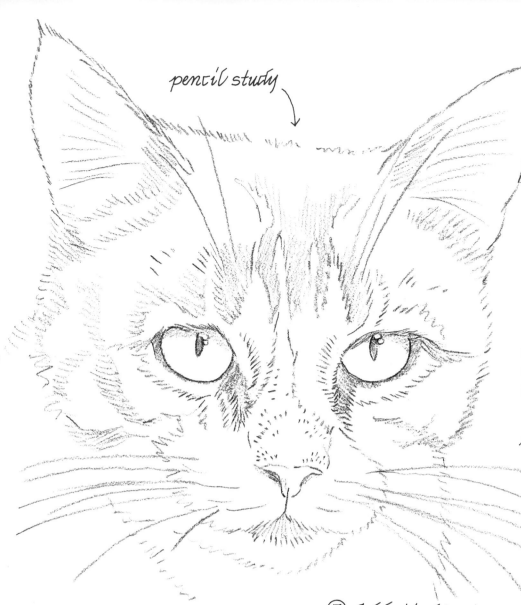

In close-up drawings like this cat portrait, facial expression becomes the main focus, although hair is still very important.

I begin my ink work in the area of the eyes because that is where the spark of life is reflected. If the finished eyes lack personality I will not bother stroking in the fur.

1. Stroke in the overlying hairs of the upper lid.

Darken the pupil, maintaining highlights.

2. Define the eye with contour lines. Darken the shadow cast by the upper lid.

3. Add stippling to represent flecks of colored pigment.

The light, crescent-shaped area depicts illumination in the eye.

4. Stroke in the hairs around the eye. Note that they grow _away_ from the eyeball.

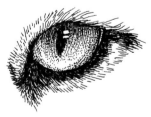

Eye placement, eyelid contours and pupil shape vary greatly according to species and even varied breeds within a species. Each must be sketched accordingly. Compare the eyes on the right.

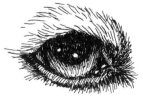

German Shepherd

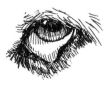

Basset hound

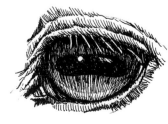

horse

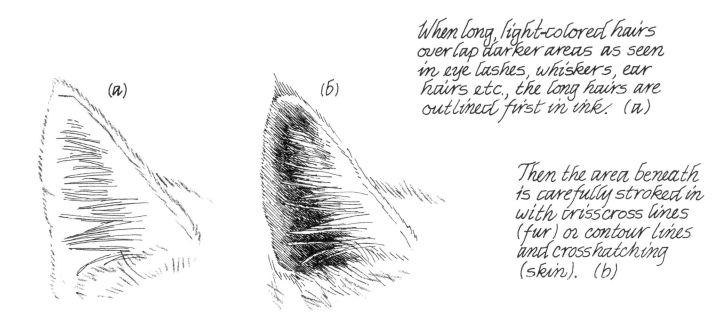

(a)          (b)

When long, light-colored hairs overlap darker areas as seen in eye lashes, whiskers, ear hairs etc., the long hairs are outlined first in ink. (a)

Then the area beneath is carefully stroked in with crisscross lines (fur) or contour lines and crosshatching (skin). (b)

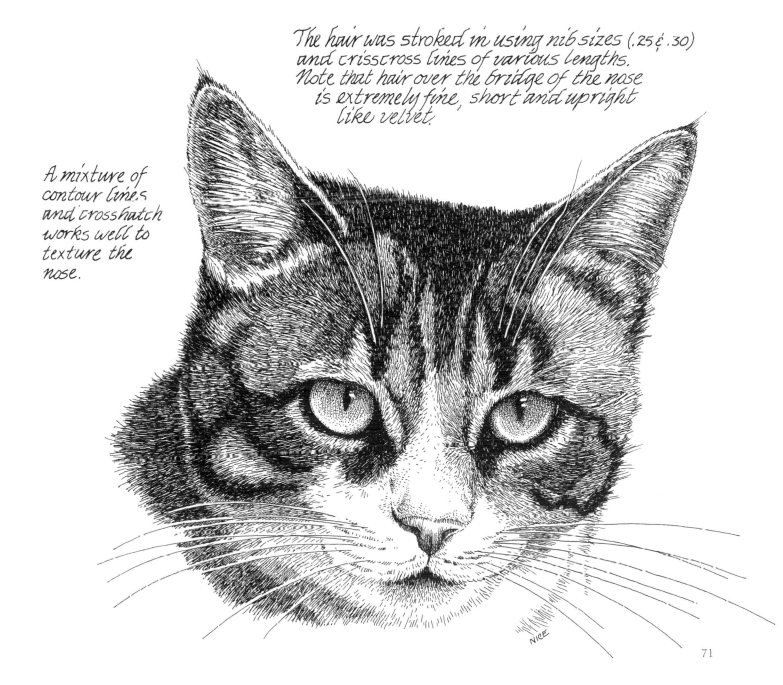

The hair was stroked in using nib sizes (.25 & .30) and crisscross lines of various lengths. Note that hair over the bridge of the nose is extremely fine, short and upright like velvet.

A mixture of contour lines and crosshatch works well to texture the nose.

# Sketching Birds

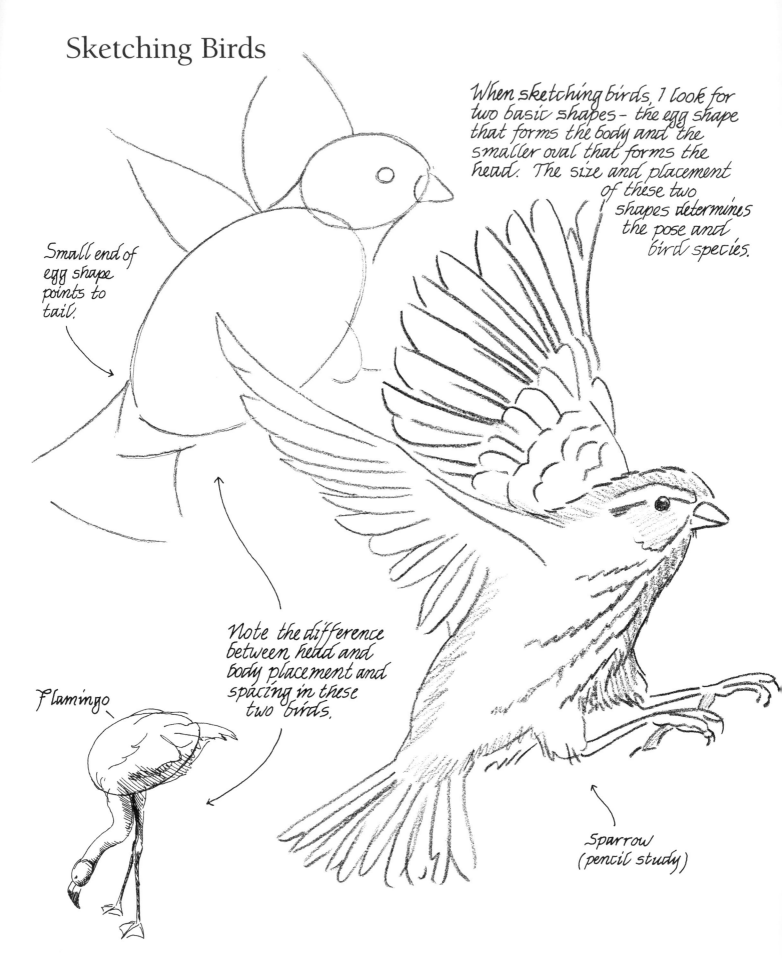

When sketching birds, I look for two basic shapes - the egg shape that forms the body and the smaller oval that forms the head. The size and placement of these two shapes determines the pose and bird species.

Small end of egg shape points to tail.

Note the difference between head and body placement and spacing in these two birds.

Flamingo

Sparrow (pencil study)

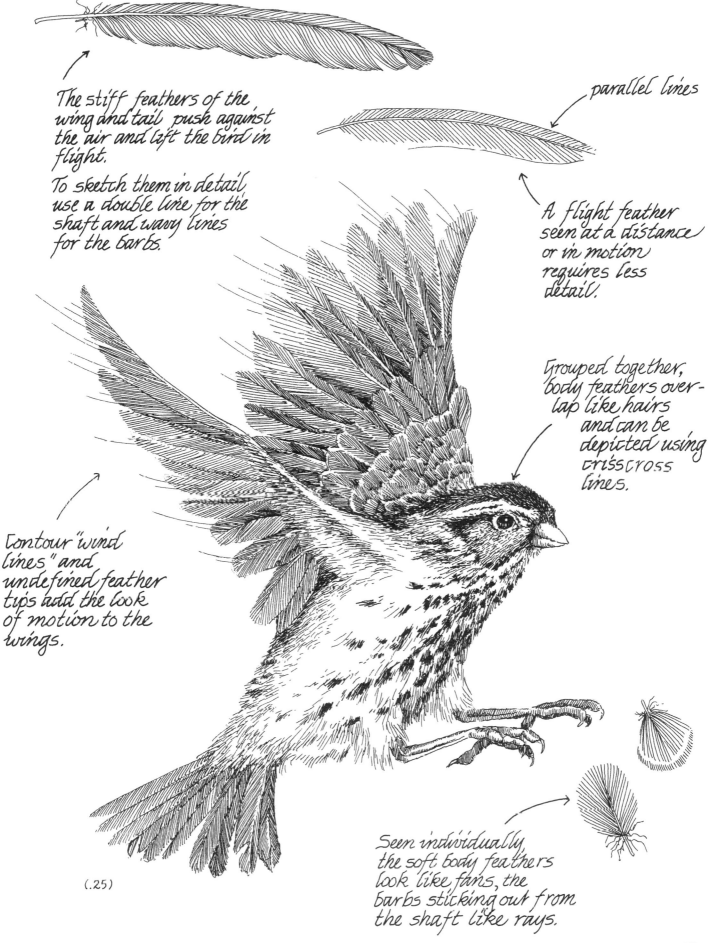

The stiff feathers of the wing and tail push against the air and lift the bird in flight.

To sketch them in detail use a double line for the shaft and wavy lines for the barbs.

parallel lines

A flight feather seen at a distance or in motion requires less detail.

Grouped together, body feathers overlap like hairs and can be depicted using crisscross lines.

Contour "wind lines" and undefined feather tips add the look of motion to the wings.

(.25)

Seen individually the soft body feathers look like fans, the barbs sticking out from the shaft like rays.

73

# Portraying the Human Figure

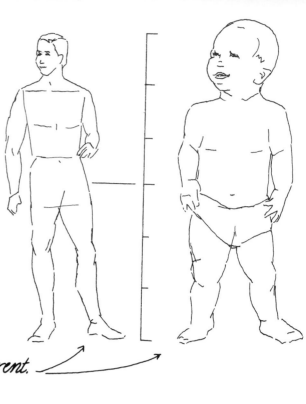

Before you pick up your pencil and pen, pause to consider the proportions of the human form and how the parts relate to each other. Live models are best for this as photos are often distorted.

The adult form and that of an infant are proportionally different.

I begin my figure drawings by roughing in the torso area.

It helps to visualize the trunk as two trapezoid shaped "building blocks" which are hinged at the waist.

The blocks are usually at slight angles to one another.

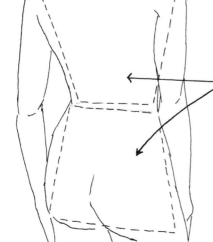

Elongated ovals work well to block in arms and legs, but keep these two characteristics in mind ---

1. Arms and legs are asymmetrical.
2. Even when fully extended, arms and legs are not straight.

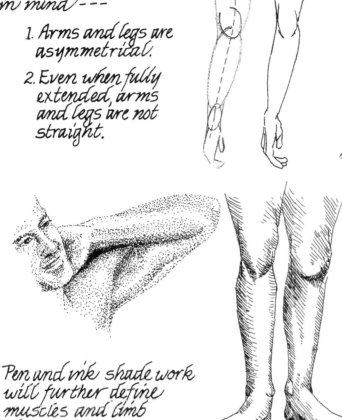

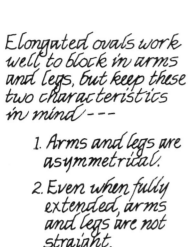

Pen and ink shade work will further define muscles and limb shape.

Foreshortened areas must be studied and drawn "by eye."

Just draw what the eye actually sees!

The weight-bearing portion of the body can be identified by running a vertical "plumb line" down from the base of the neck. Still figures must have a means of balance and support.

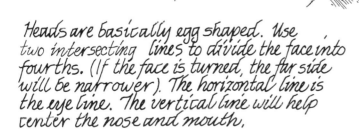

Heads are basically egg shaped. Use two intersecting lines to divide the face into fourths. (If the face is turned, the far side will be narrower). The horizontal line is the eye line. The vertical line will help center the nose and mouth.

The bottom of the nose is located halfway between the eyebrows and chin. The ears line up with the nose.

Locate the mouth one-third the distance from the bottom of the nose to the chin.

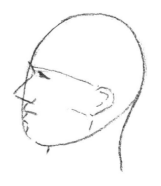

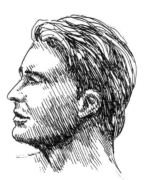

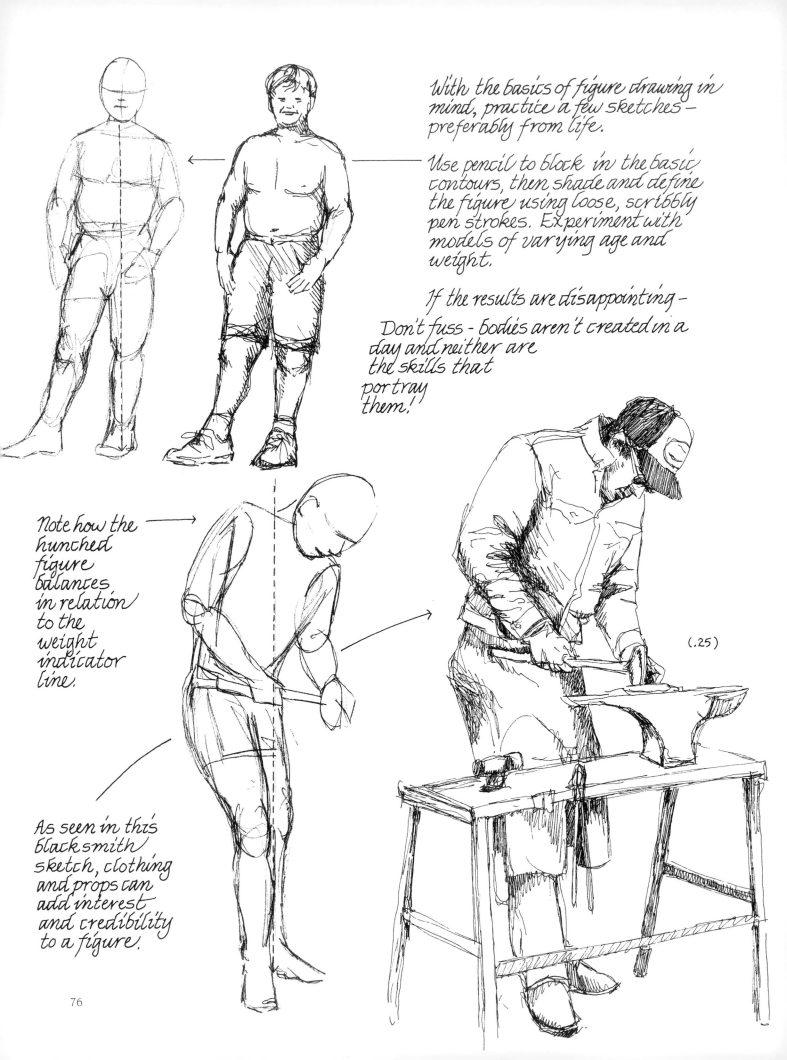

With the basics of figure drawing in mind, practice a few sketches - preferably from life.

Use pencil to block in the basic contours, then shade and define the figure using loose, scribbly pen strokes. Experiment with models of varying age and weight.

If the results are disappointing -

Don't fuss - bodies aren't created in a day and neither are the skills that portray them!

Note how the hunched figure balances in relation to the weight indicator line.

As seen in this blacksmith sketch, clothing and props can add interest and credibility to a figure.

(.25)

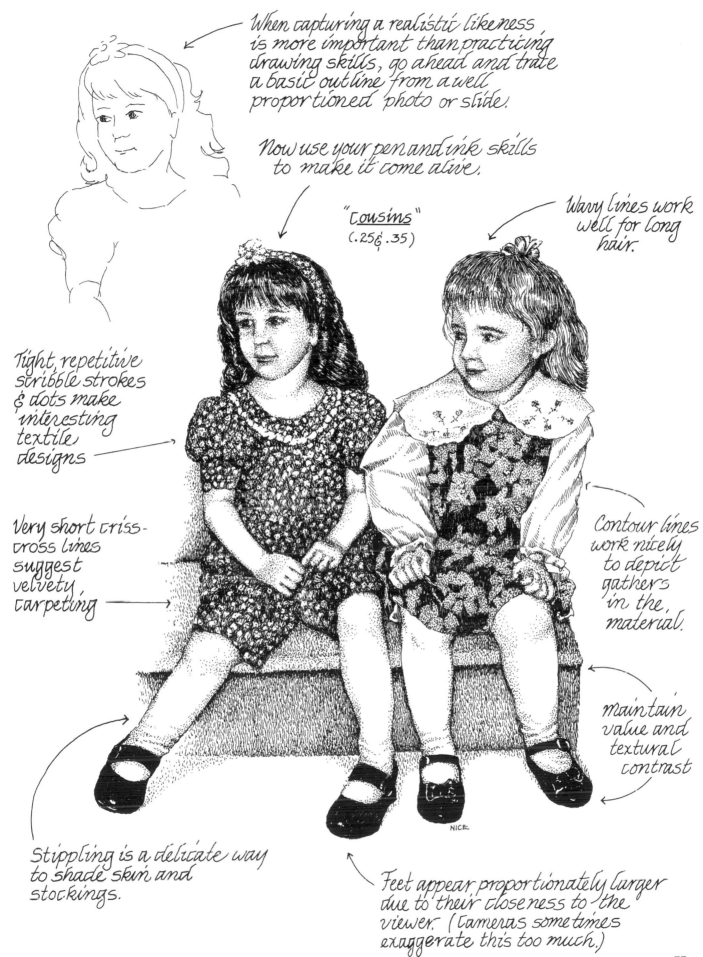

When capturing a realistic likeness, is more important than practicing drawing skills, go ahead and trace a basic outline from a well proportioned photo or slide.

Now use your pen and ink skills to make it come alive.

"Cousins"
(.25 & .35)

Wavy lines work well for long hair.

Tight, repetitive scribble strokes & dots make interesting textile designs

Very short criss-cross lines suggest velvety carpeting

Contour lines work nicely to depict gathers in the material.

maintain value and textural contrast

Stippling is a delicate way to shade skin and stockings.

Feet appear proportionately larger due to their closeness to the viewer. (Cameras sometimes exaggerate this too much.)

NICE

Preliminary pencil drawings for portrait-sized faces begin in the same manner as small ones.

The head is slightly tilted. Note how the facial features slant accordingly, guided by the eye line.

A loose, sketchy mixture of wavy line and scribble strokes work well to suggest long, flowing locks.

Features defined in pencil

Begin ink texturing in the area of the eyes.

Stippling provides a subtle blending of skin tones, and is very forgiving.

Crosshatching lends a bold, dramatic look to skin contours.

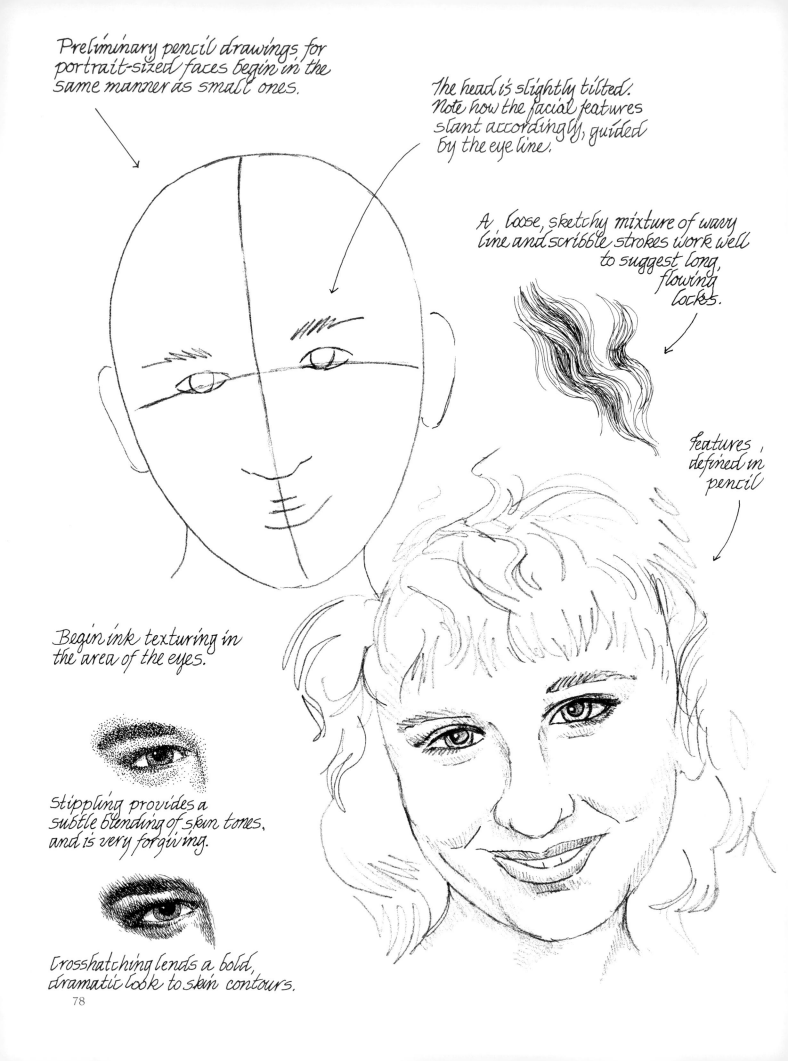

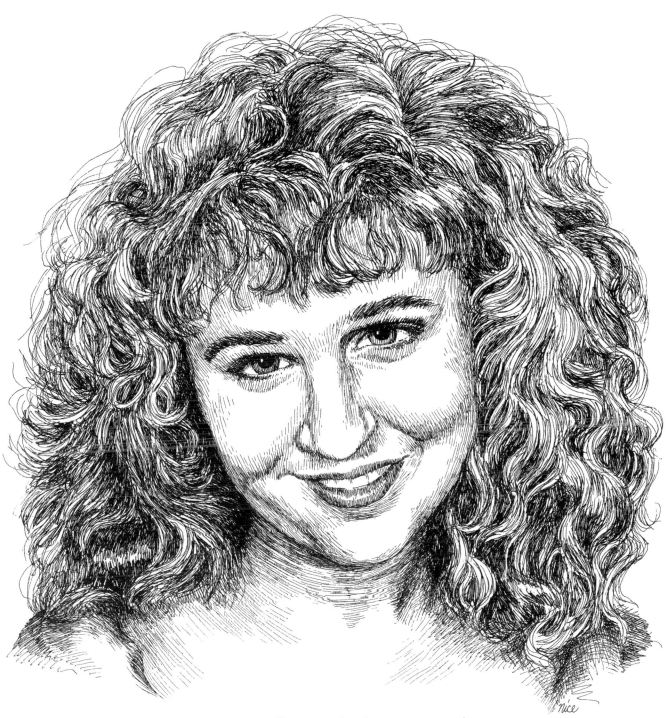

This detailed ink portrait of
my daughter took twelve hours to
complete. Because of the time
involved, most of my pen and ink
portraits are sketched from slides
or photos.

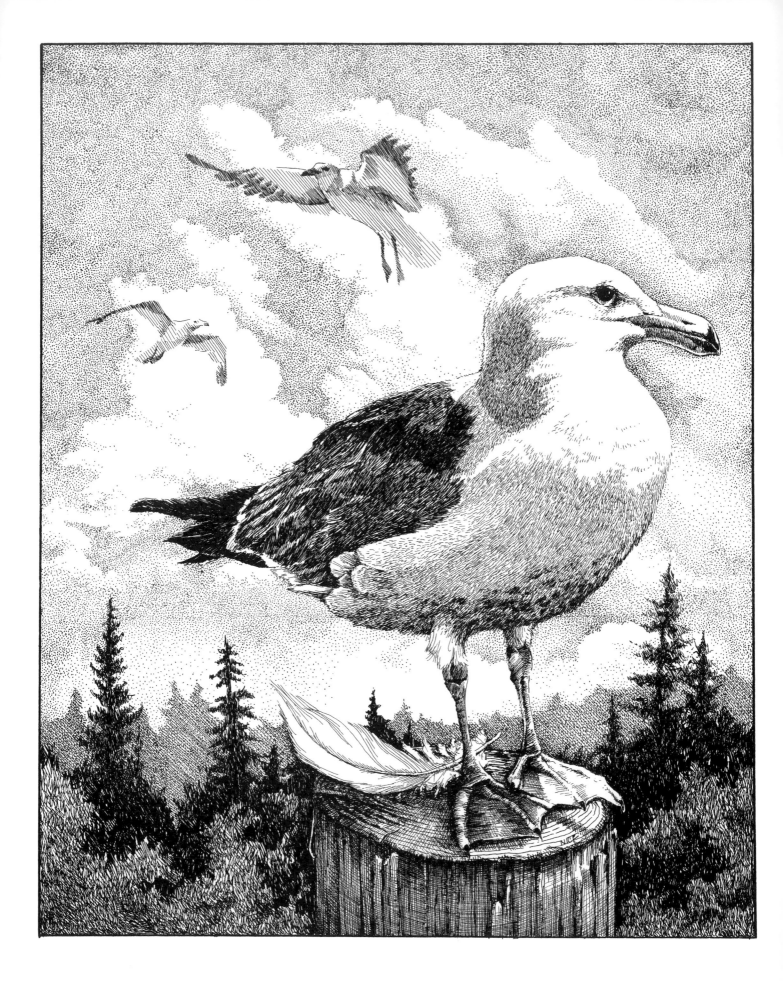

# Chapter Four

# PUTTING IT ALL TOGETHER

When the pen feels natural in your hand and the sketching pencil no longer strikes fear in your heart, you are ready to put it all together and compose a finished drawing. The *composition* of your drawing is simply the arrangement of your chosen subject, shapes, values and textures upon the paper. The placement of your subjects is often more important than your ability to draw them. In fact, a good design can catch the eye, even when the *elements* of the design aren't anything recognizable. You can find plenty of examples hanging in museums.

In a well designed ink composition, the viewer is drawn into the piece by an interesting shape, striking contrast or bold texture. This eye catcher should point to, surround or actually be part of the main subject. Now that you have gotten the viewer's attention, take him or her on a tour of your art piece by building a continuous pathway of interest for the eye to follow. Vertical shapes, shadows and texture zones lead the eye upward; horizontal elements lead the viewer across the page. Straight lines direct the eye with authority, while curves invite the eye to move along at a slower, meandering pace.

In pen work, the eye will usually notice the darkest areas first, followed by the busy, gray textured zones. White open zones and negative spaces provide a spot for the eye to linger and rest. All three are important to the design of your composition.

Study the design plan for the gull drawing on the opposite page. The center of interest is the largest gull. The dark areas of the back, eye and beak are the focus points. The dark tree areas were arranged to keep the eye circling. The cloud formations and small sea gull shapes serve the same purpose above the main subject.

The following pages will provide a few design hints to help you get started. Experiment with some of the step-by-step projects provided. Rearrange the subjects shown and substitute your design ideas. Before you know it, you will be doing more than just drawing with the pen: You will be creating your own original pieces.

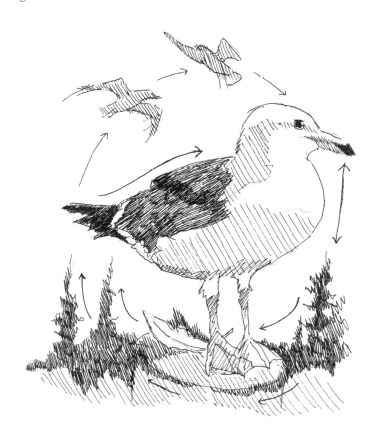

# Planning a Composition

①) Choose a format that fits the dimensions of your subject.

A work surface which is taller than it is wide is called a "Portrait format." It works well for subjects of a vertical nature.

Formats that stretch horizontally are called "landscape" and are appropriate for subjects that sweep sideways.

Wrong format ~ too much empty space.

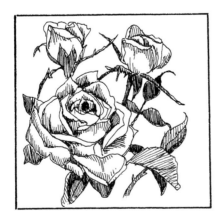

Round or crescent shaped groupings may work best in a square or oval format.

A quick thumb nail sketch will give you an idea of how it will look!

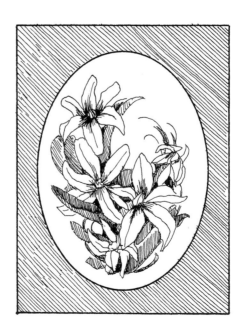

② Avoid cutting your composition in half with strong lines or shapes that rest dead center.

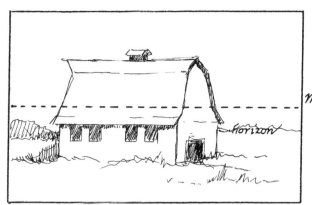 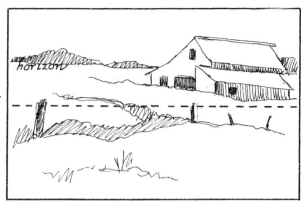

midpoint

Place horizon lines somewhere below or above midpoint.

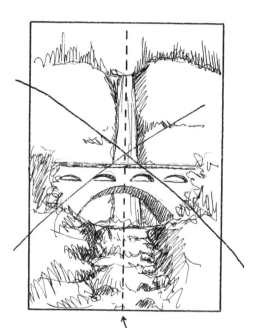 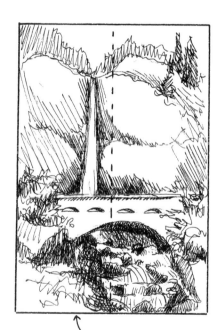 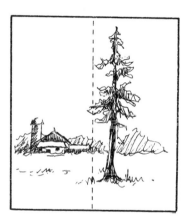

Strong vertical images need to be placed off-center.

↑ Centered waterfall divides drawing in half.

↑ Better arrangement

Choosing the main focal point ~

Divide your paper in thirds, vertically and horizontally. Where the lines cross are prime main subject locations.

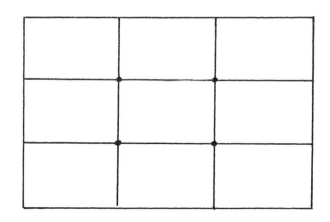

③ Strive for a natural, slightly imperfect balance, the way Mother Nature arranges things.

  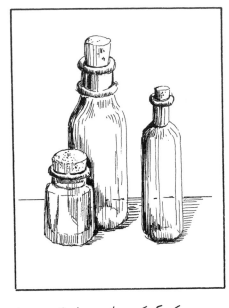

perfect balance - boring!       unbalanced - one-sided!       imperfect, natural balance -

Unequal numbers, sizes and shapes are easiest to work with.

As you plan your design, think of the points of a triangle. Plan to have at least three dark value areas, busy gray texture zones and light value areas.

Use more if you wish, but maintain imperfect balance.

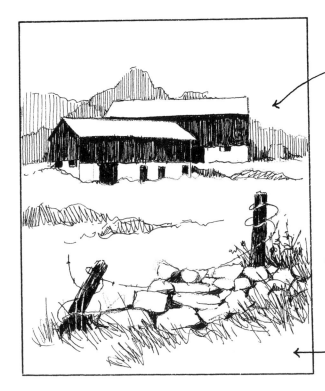

The buildings and two fence posts provide a triangle of dark values and a mixture of horizontal and vertical shapes which guide the eye in a circular path.

Light value areas keep the composition from looking over-worked.

④ Beware of distraction booby traps.

When any one part of the composition commands overpowering attention, the overall harmony of the drawing may be spoiled.

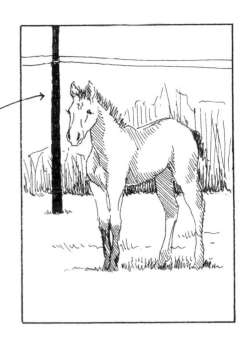

The telephone pole in this sketch of a foal is very distracting. Its value is much darker than the rest of the composition, and it serves no useful purpose.  Take it out!

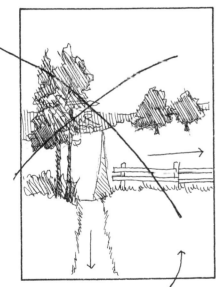

Distracting! ~ Straight lines lead the eye out of the drawing.

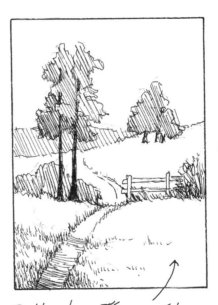

Better! ~ The road is now gently curved and "blocked" with shadows. A bush is added to soften the fence line.

Avoid strong lines and shapes that direct the eye out of the composition.

Straight lines can be changed into gentle curves or blocked with the addition of intersecting shapes.

Remember ~

These are hints and not absolute rules. Artistic license gives you the right to do it your way.

# Sketching Outdoors

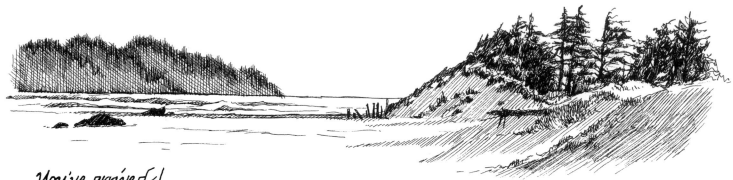

You've arrived!
You're on location, pen and paper in hand.
Before you is 360 degrees of beach scenery, pastoral farmland,
mountain meadows or whatever.

First decision - what should you sketch?

Zero in on the subject that most
interests you.

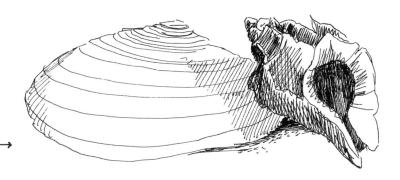

- A section of distant
  landscape
- A main subject like a
  house, tree, cow, etc.
- A still life grouping of
  "found objects."
- The close up details
  of a shell, leaf
  snail or whatever
  catches your eye.

Once you've selected your subject
matter, add only those elements
needed to create a good composition.
<u>Avoid the temptation to draw every-
thing you see!</u>

If you've decided to do
a series of quick sketches
in your field journal,
you need only capture
the essence of the
subject with a few
scribbly strokes. ⟶

Time is a factor to consider when working outdoors in natural lighting. Shadows change quickly or worse, disappear altogether. Note them right away in your preliminary pencil sketch.

Morning or late afternoon sketching will provide the best shadows and contrasts of value.

Plan projects that can be finished in an hour or less, or take back-up photos so that the drawing can be completed at a later date. Don't rely on your memory for finishing details.

## Supplies for a field sketch kit ~

. Grumbacher Artist Pens sizes extra fine, fine & medium
                    or
. .25, .35 & .50 Rapidograph pens, plus Universal Black India Ink and cleaning kit.

. Mechanical pencil and white vinyl eraser.

. A small sketch pad or bound sketch journal suitable for pen and ink.

. A 6 inch clear plastic ruler.

. A small plastic water container for washes and clean-up. Lint-free rag.

. A no. 4 round brush *

. One bottle correction fluid *

. Watercolors for washes *

* optional

## Weather ~ Plan for it!

Sunlight can be blinding as it reflects off a white sketch pad. Try to face away from it or work in the shade.

Carry drinking water, sun screen lotion, bug repellent and a small first-aid kit. Wear a wide-brim hat and loose, light-colored clothing.

In rain and wind you will need some kind of shelter ~ a car, cabin, porch, tent or tarp.

Carry an umbrella, hot drink thermos, folding chair or waterproof cushion and rain gear.

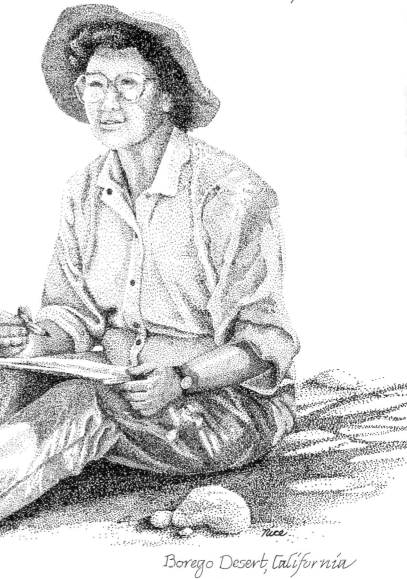

Borego Desert, California

# Working From Photos

Although I enjoy sketching from life, I have found photos to be a valuable resource in my artwork. Only through photography can I stop the movement of animals and children, still the crashing surf or preserve the transient shadows of a still life.

When possible, take your own photos so that you can arrange the subjects or choose the view that best meets the requirements of a good composition!

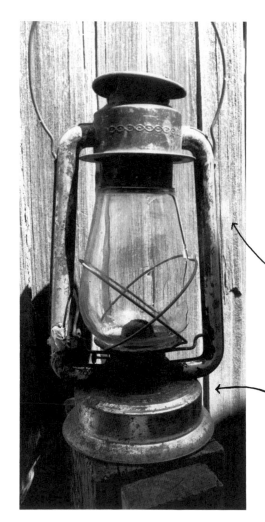

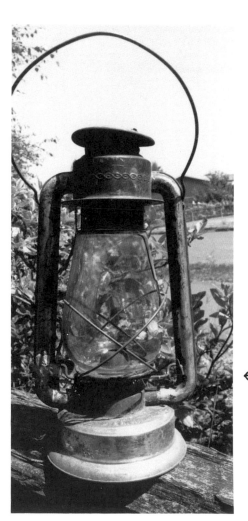

A plain background works best when photographing still life subjects.

Bright, natural lighting will yield good highlights and shadows --- an artists delight!

← Here, the busy background has made the highlights and shadows on the glass lamp, hard to see.

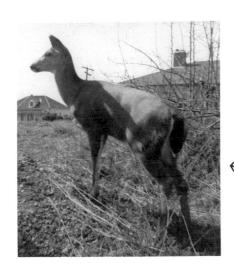

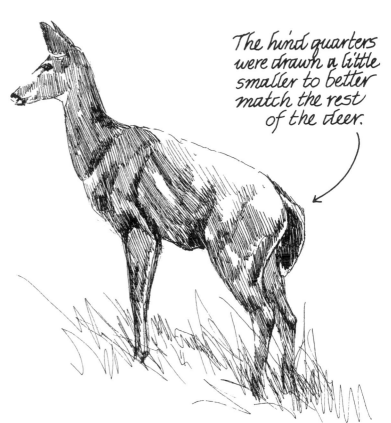

The hind quarters were drawn a little smaller to better match the rest of the deer.

Beware of photo distortion.

The camera does not always record images with the accuracy of the human eye. Note how large the hind quarters of this deer look compared to the rest of the body.

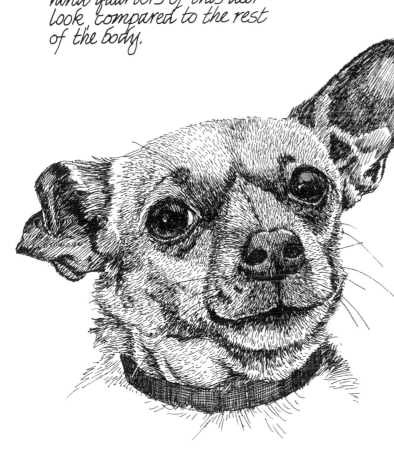

It's fun to combine the subjects from several photos into one drawing, but make sure that both perspective and lighting are compatible.

The light is coming from different directions in these two photos, making them hard to combine.

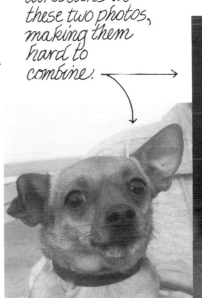

In order for a photo to be used as the basis of an animal portrait, the image must be well-defined.

I like to be able to see individual hairs in the coat.

89

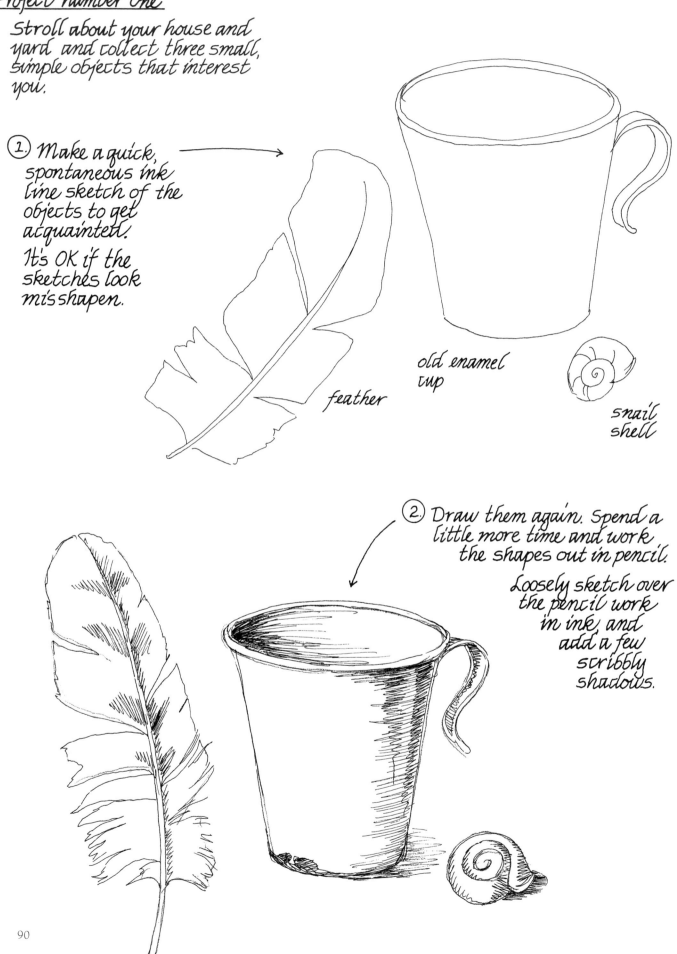

Stroll about your house and yard and collect three small, simple objects that interest you.

① Make a quick, spontaneous ink line sketch of the objects to get acquainted.

It's OK if the sketches look misshapen.

feather

old enamel cup

snail shell

② Draw them again. Spend a little more time and work the shapes out in pencil.

Loosely sketch over the pencil work in ink, and add a few scribbly shadows.

90

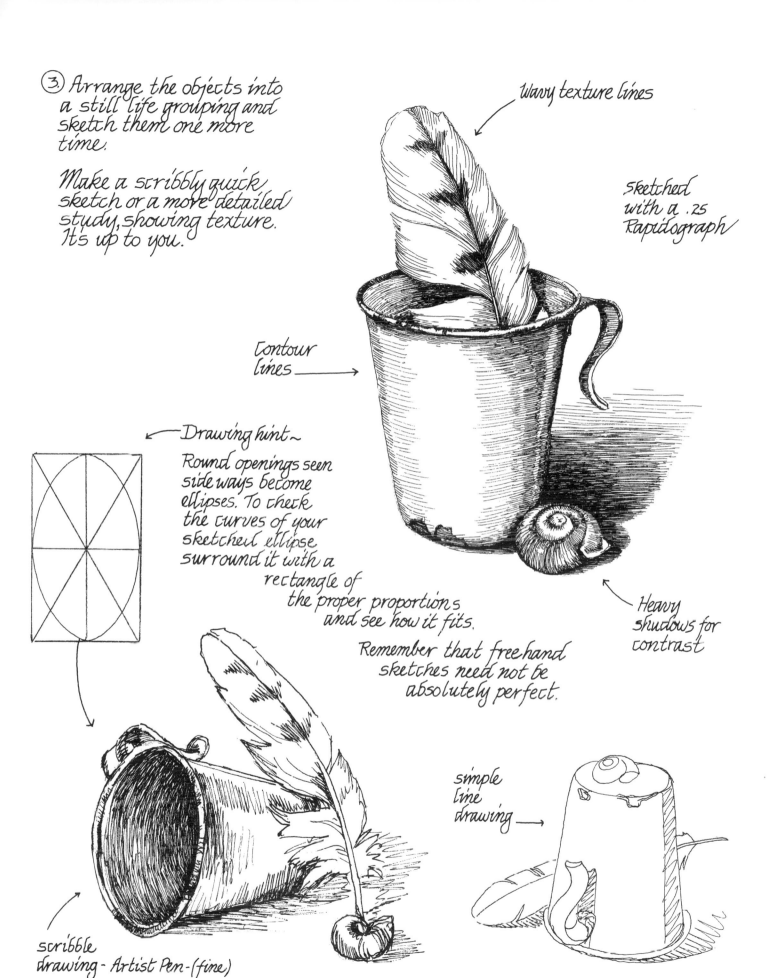

3. Arrange the objects into a still life grouping and sketch them one more time.

Make a scribbly quick sketch or a more detailed study, showing texture. It's up to you.

wavy texture lines

Sketched with a .25 Rapidograph

Contour lines

Drawing hint ~
Round openings seen sideways become ellipses. To check the curves of your sketched ellipse surround it with a rectangle of the proper proportions and see how it fits.

Remember that freehand sketches need not be absolutely perfect.

Heavy shadows for contrast

scribble drawing - Artist Pen - (fine)

simple line drawing

## Project Number Two

Try your hand on these fear-conquering mini projects. . Don't be afraid to experiment with variations.

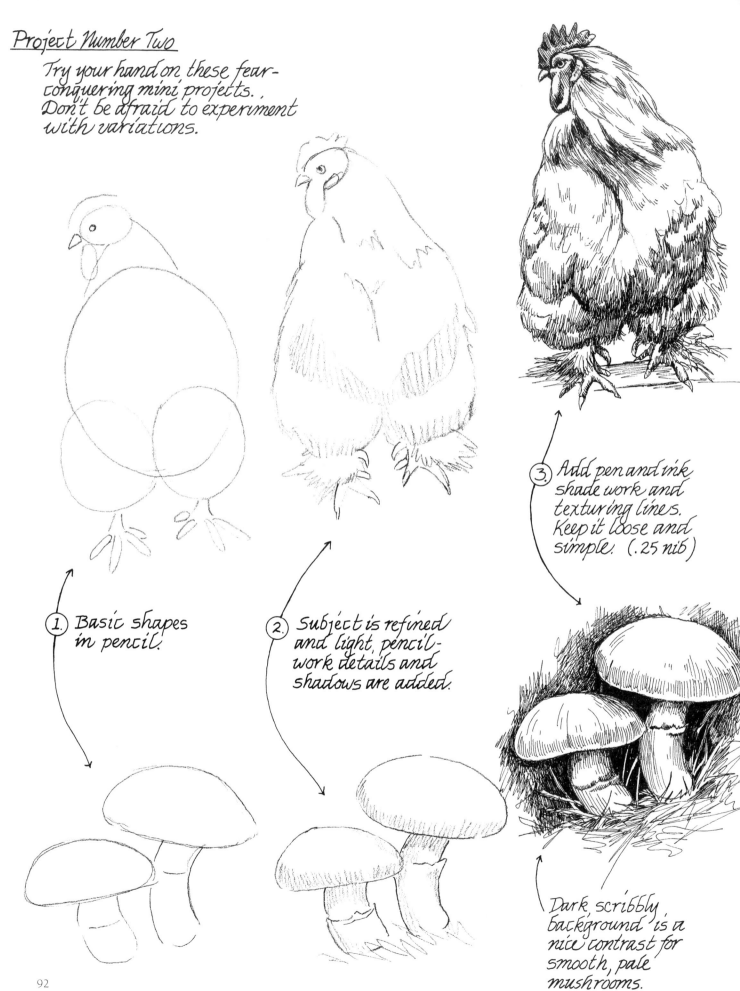

① Basic shapes in pencil.

② Subject is refined and light, pencil-work details and shadows are added.

③ Add pen and ink shade work and texturing lines. Keep it loose and simple. (.25 nib)

Dark, scribbly background is a nice contrast for smooth, pale mushrooms.

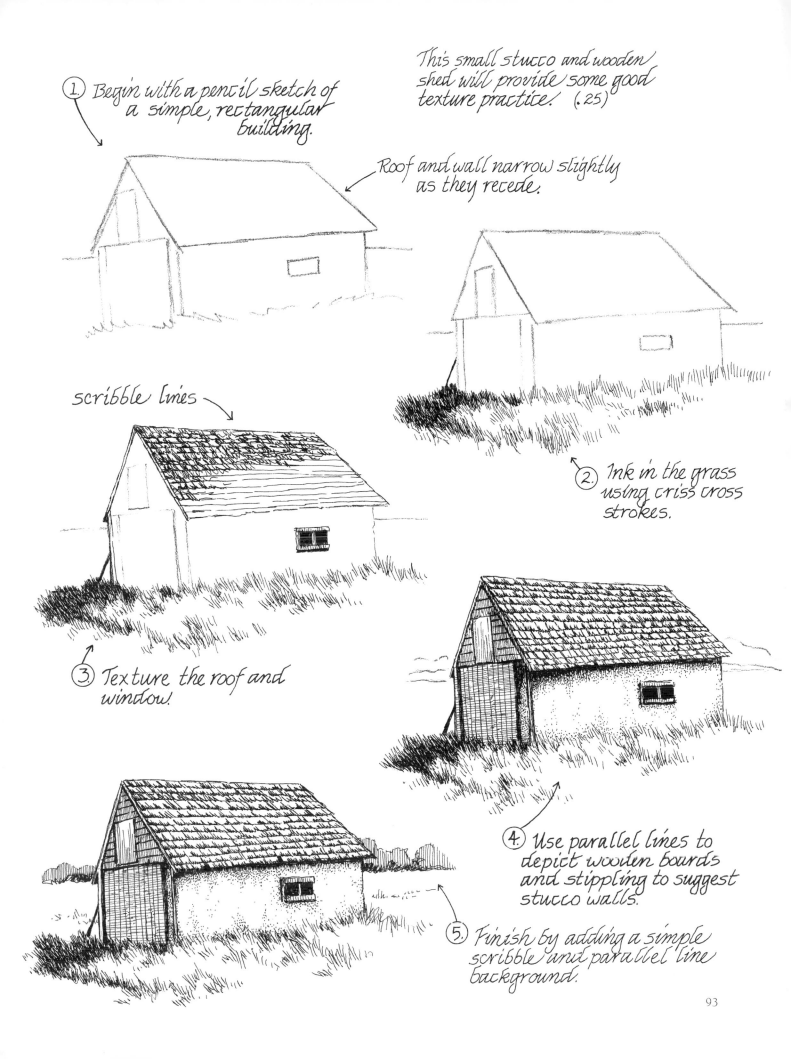

1. Begin with a pencil sketch of a simple, rectangular building.

This small stucco and wooden shed will provide some good texture practice! (.25)

Roof and wall narrow slightly as they recede.

scribble lines

2. Ink in the grass using criss cross strokes.

3. Texture the roof and window!

4. Use parallel lines to depict wooden boards and stippling to suggest stucco walls.

5. Finish by adding a simple scribble and parallel line background.

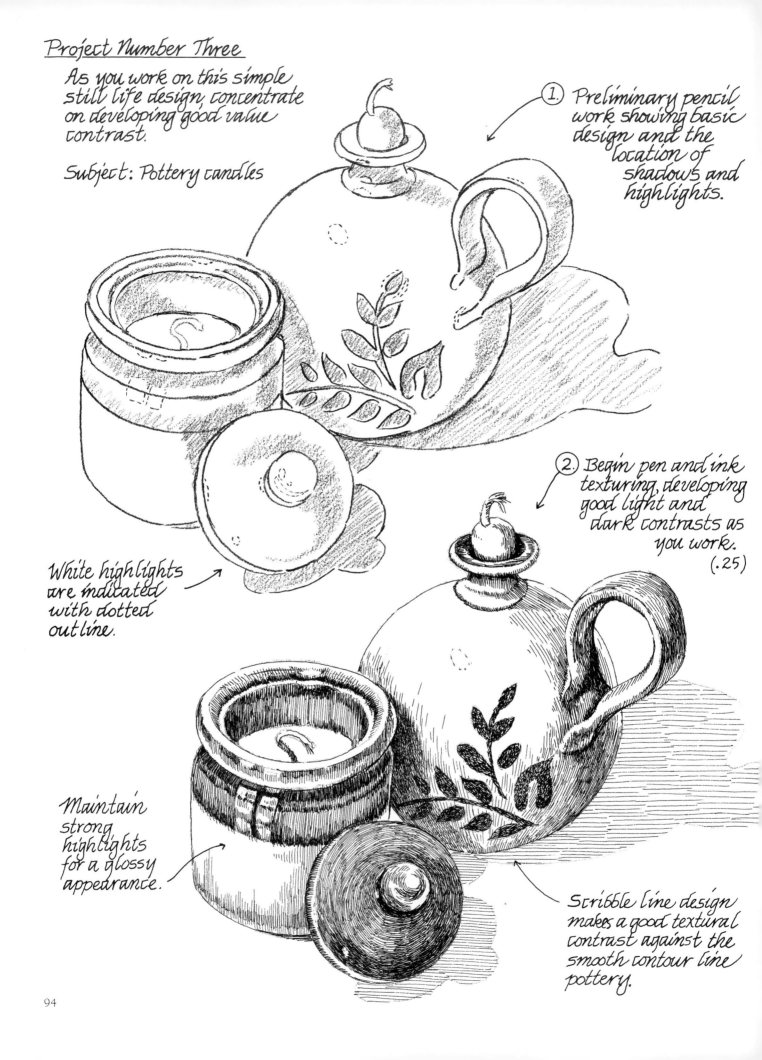

## Project Number Three

As you work on this simple still life design, concentrate on developing good value contrast.

Subject: Pottery candles

① Preliminary pencil work showing basic design and the location of shadows and highlights.

White highlights are indicated with dotted outline.

② Begin pen and ink texturing, developing good light and dark contrasts as you work.
(.25)

Maintain strong highlights for a glossy appearance.

Scribble line design makes a good textural contrast against the smooth contour line pottery.

94

The foreground is heavily worked and fairly dark, therefore the background is left open for contrast.

Cast shadows are crosshatched to provide textural variation

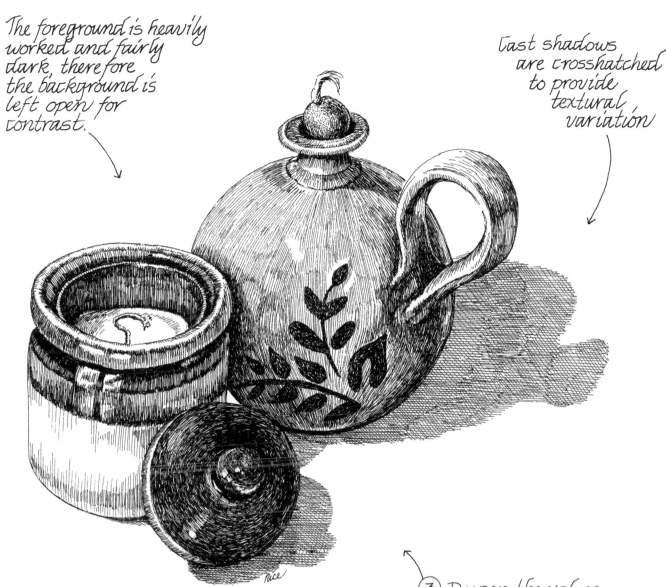

nice

③ Deepen the values by adding additional ink strokes. Maintain good contrast between gray tones and dark shadow areas.

Before it becomes an overall, monotone charcoal gray — STOP! Cap the pen and call it finished.

Inking hint:
    If a vital highlight spot should be lost, add it back in with a daub of Liquid Paper correction fluid. Wait ten minutes and blend the edges with a few pen strokes.

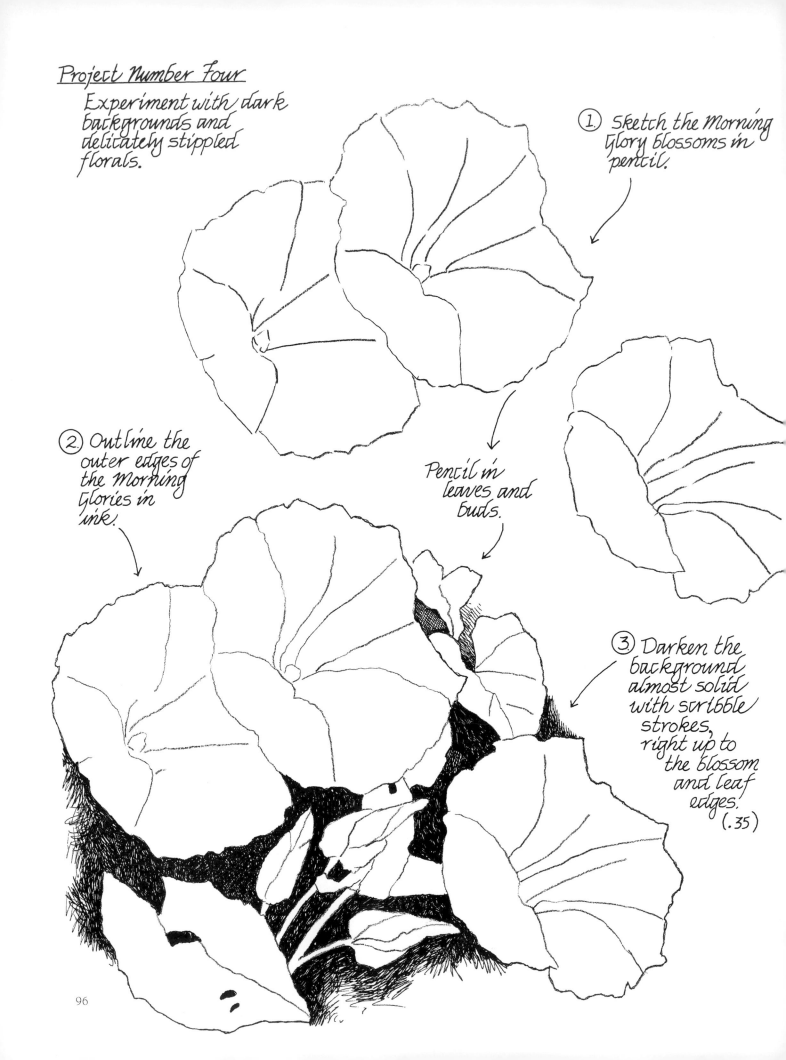

## Project Number Four

Experiment with dark backgrounds and delicately stippled florals.

① Sketch the Morning Glory blossoms in pencil.

② Outline the outer edges of the Morning Glories in ink.

Pencil in leaves and buds.

③ Darken the background almost solid with scribble strokes, right up to the blossom and leaf edges.
(.35)

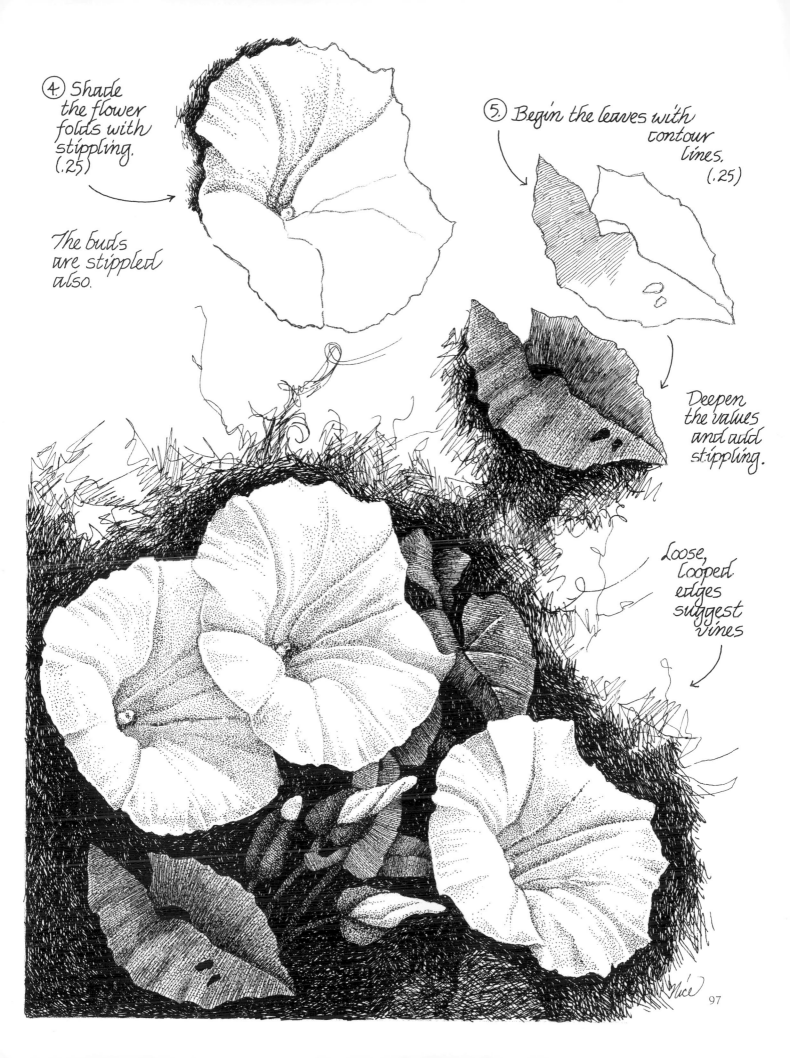

④ Shade the flower folds with stippling. (.25)

The buds are stippled also.

⑤ Begin the leaves with contour lines. (.25)

Deepen the values and add stippling.

Loose, looped edges suggest vines

Nice

97

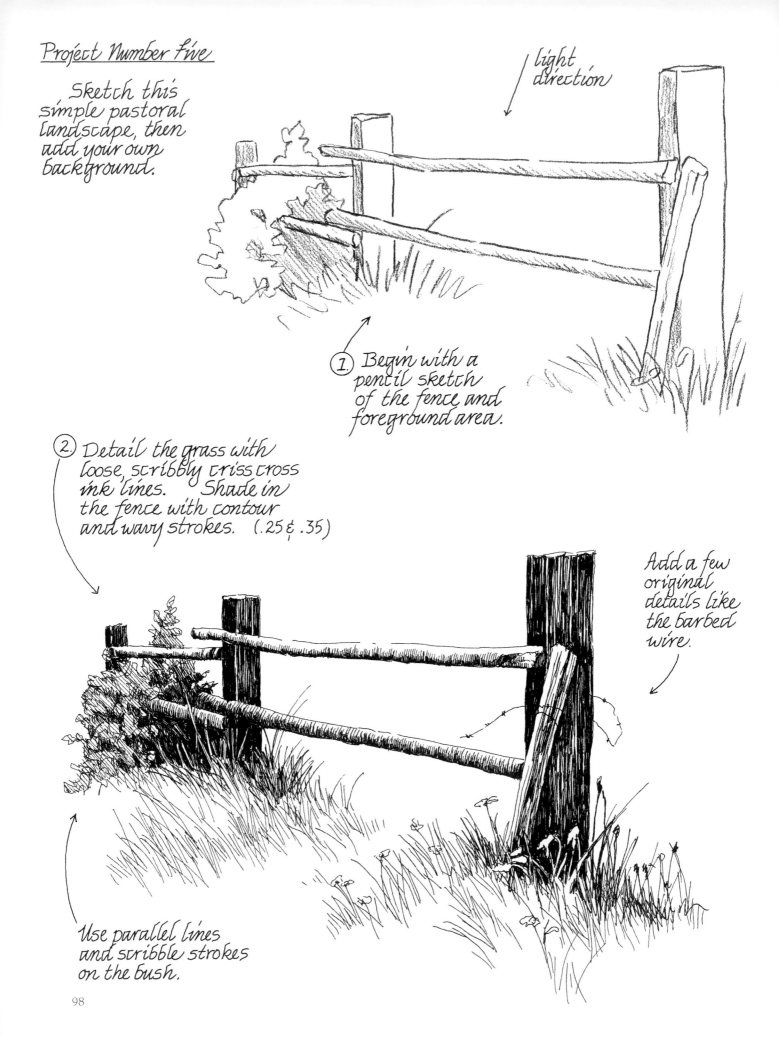

*Project Number Five*

Sketch this simple pastoral landscape, then add your own background.

light direction

① Begin with a pencil sketch of the fence and foreground area.

② Detail the grass with loose, scribbly criss cross ink lines. Shade in the fence with contour and wavy strokes. (.25 & .35)

Add a few original details like the barbed wire.

Use parallel lines and scribble strokes on the bush.

③ Create an original background for the landscape. Work your idea out lightly in pencil, keeping in mind the light direction you have already established. Keep the design simple.

When you're happy with the preliminary pencil layout, commit it to ink.

Background suggestions —

- One of the simple barns shown in the previous chapter
- Let the fence rest on a hill top with a cloud formation behind.
- Add a familiar rural background from your own part of the country.

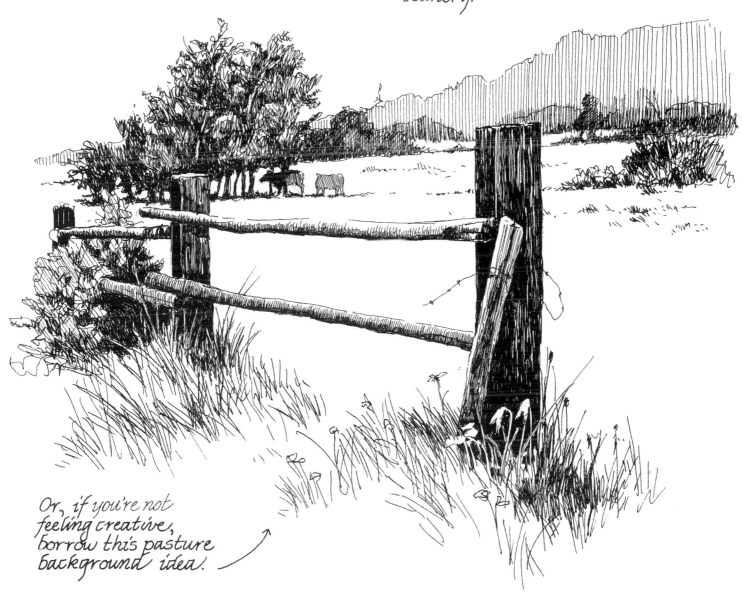

Or, if you're not feeling creative, borrow this pasture background idea.

## Project Number Six

Placing a rustic out-building in a country setting makes a nice landscape with a nostalgic mood. Practice this one, then create one of your own.

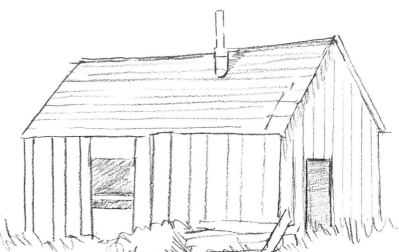

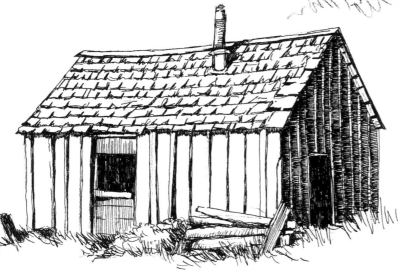

All of these simple out-buildings share the same perspective and lighting, and will fit nicely into the practice landscape. Choose one or add a similar structure from your own photo files.

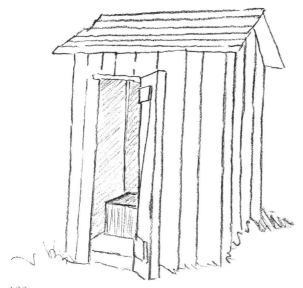

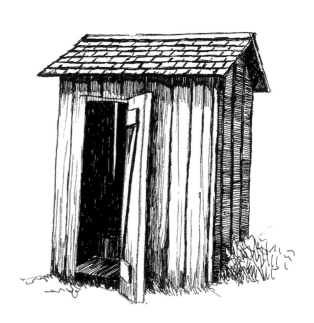

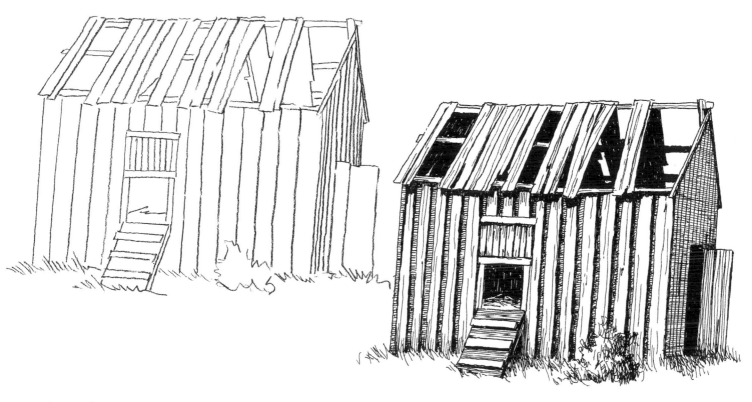

Landscape idea, set down in a quick-sketch, scribbly format to test its general appearance.

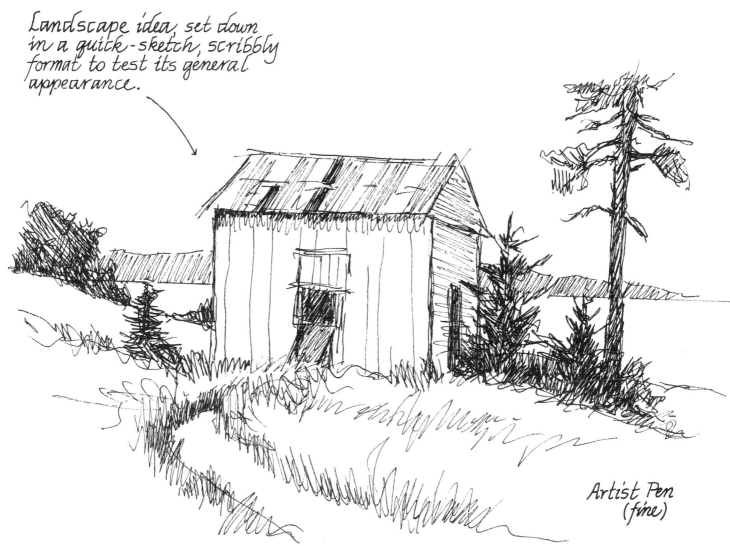

Artist Pen
(fine)

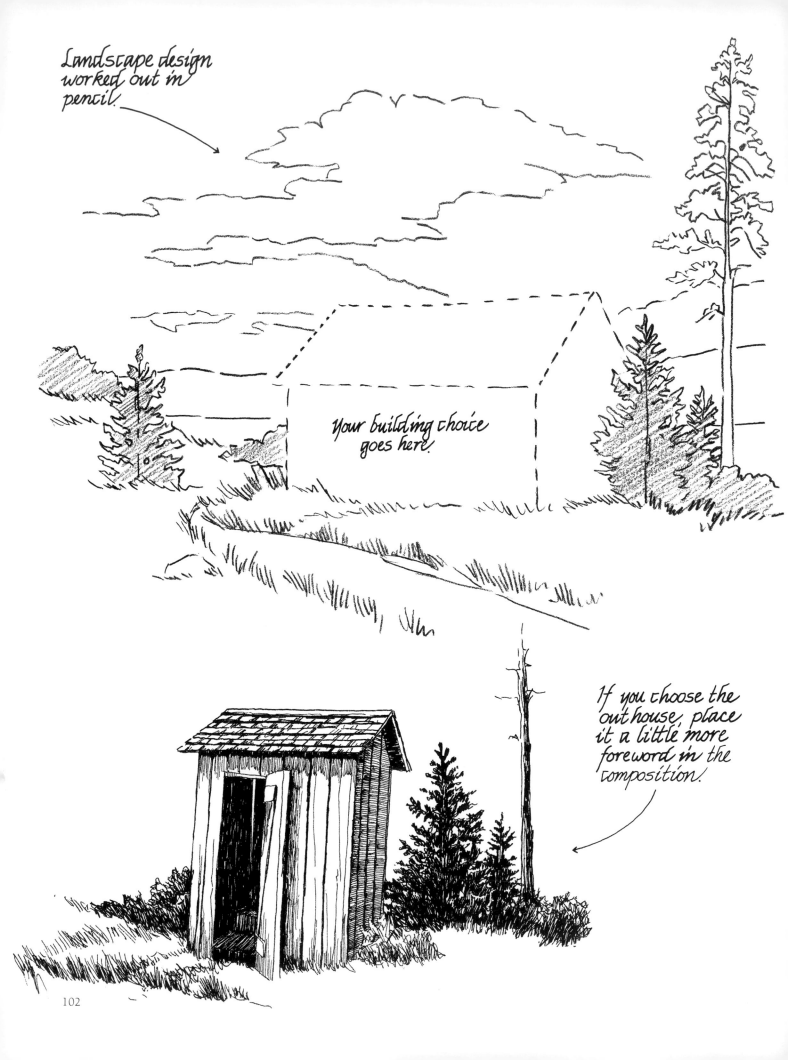

Landscape design worked out in pencil.

Your building choice goes here.

If you choose the out house, place it a little more foreword in the composition.

Pen sizes .25 and .35 were
used to detail and texture
the finished landscape.

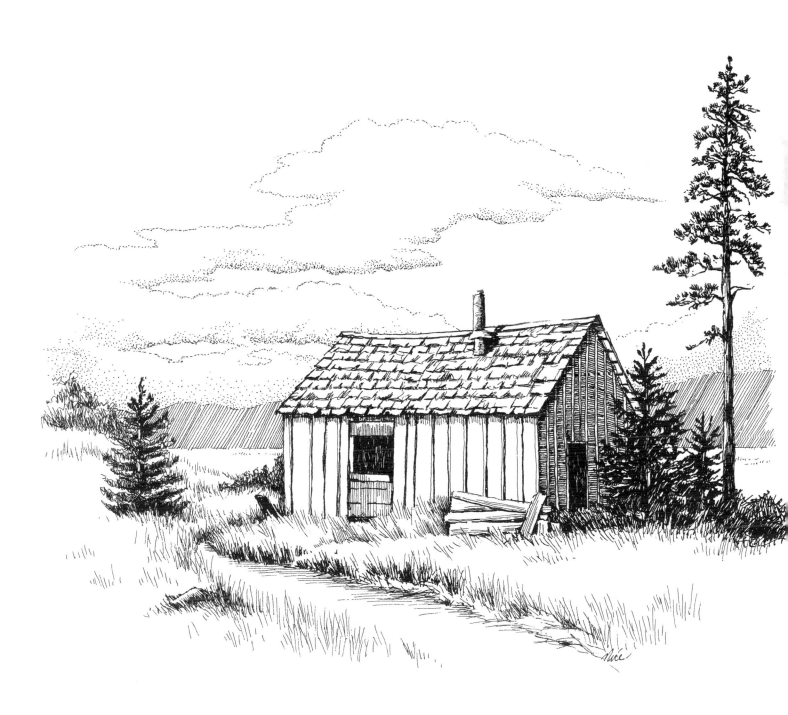

103

## Project Number Seven

Following the steps I took in painting this old railroad station will provide an opportunity to experiment with washes.

Preliminary drawing sketched in pencil

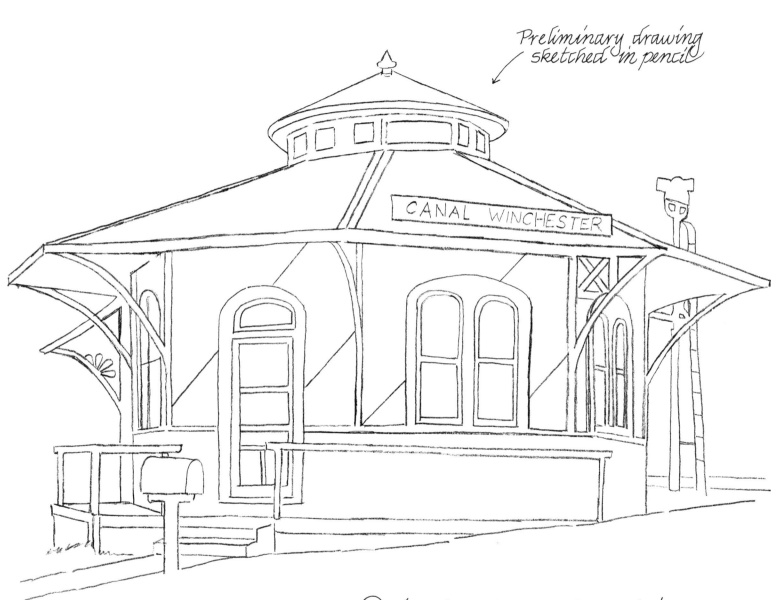

① Transfer or free-sketch the design onto heavy pen and ink sketching paper or a sheet of cold-pressed 125 lb watercolor paper.

I used Grumbacher Meridian drawing paper for the original project.

② Mix India ink or black, Indigo or Payne's Gray watercolor with water to form a wash. Vary the amount of water in the mix to determine the value.

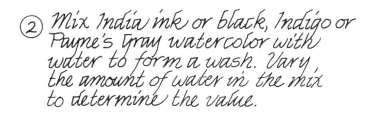

Using a number four round brush, stroke the shadow areas with washes of gray tint.

Caution: If you are working on drawing paper, over-wetting an area will cause it to buckle!

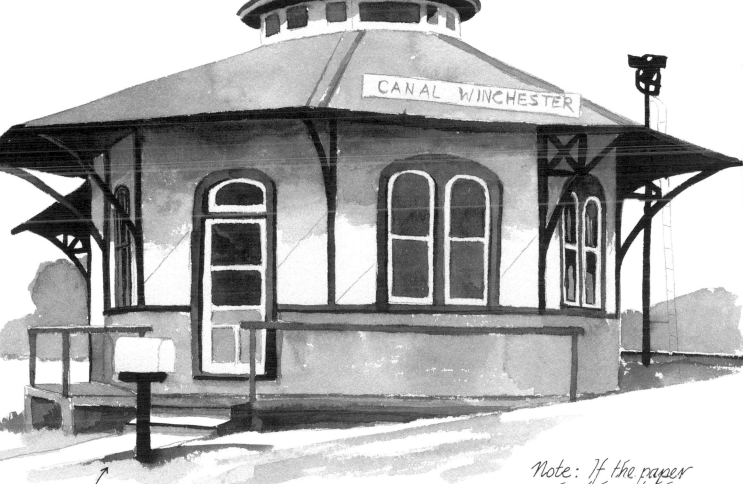

CANAL WINCHESTER

If you wish to darken a previously tinted area, let the first wash layer dry, then stroke a second wash gently over it.

Note: If the paper should wrinkle, try pressing it flat again on the back side, with a warm, dry iron!

105

③ Use a .25 sized pen to add definition and texture.

stippling

A combination of of stippling and scribble strokes

Washed areas do not need ink outlines.

CANAL WINCHESTER

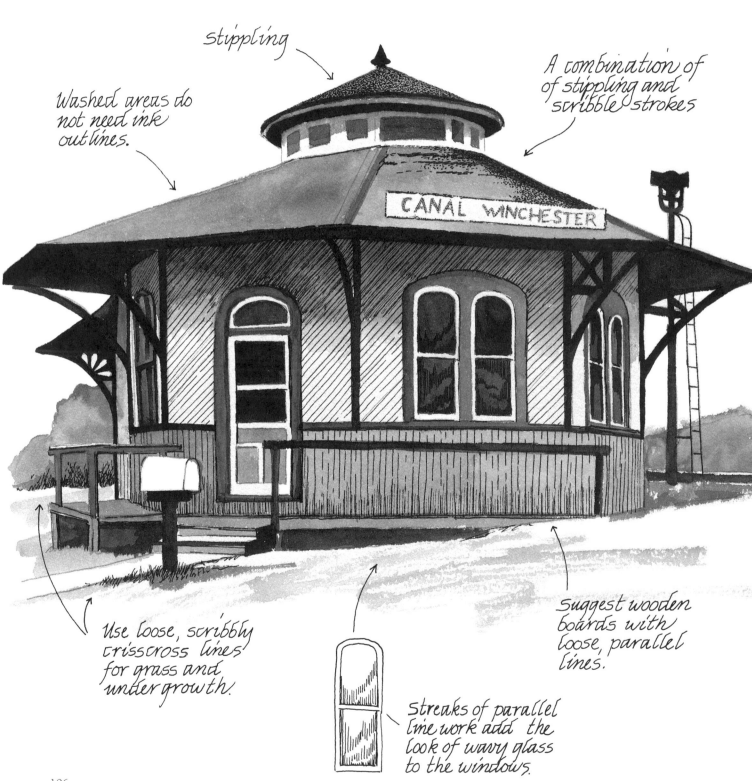

Use loose, scribbly crisscross lines for grass and undergrowth.

Suggest wooden boards with loose, parallel lines.

Streaks of parallel line work add the look of wavy glass to the windows.

The finished project displays the best features of two mediums...

The bold impact of ink texturing and the subtle soft qualities of washed tints.

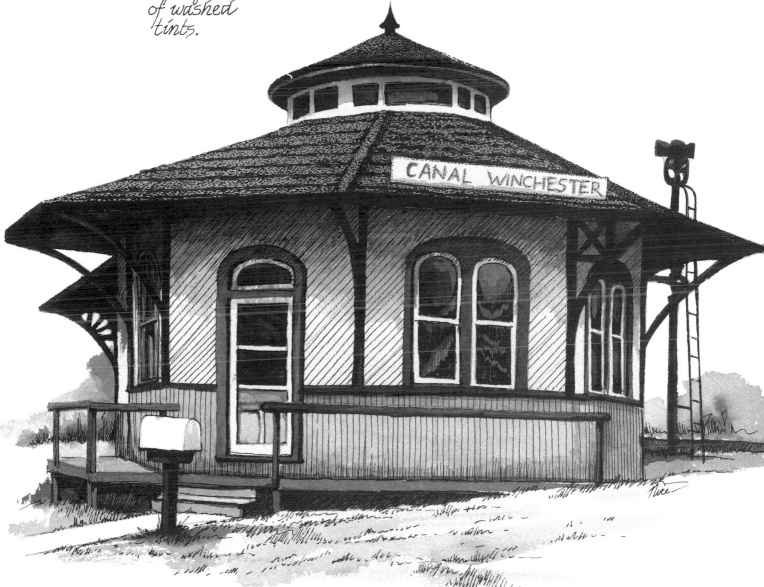

CANAL WINCHESTER

This technique works well with brown and sepia colored inks and washes, the result reminding one of the old tin type photography.

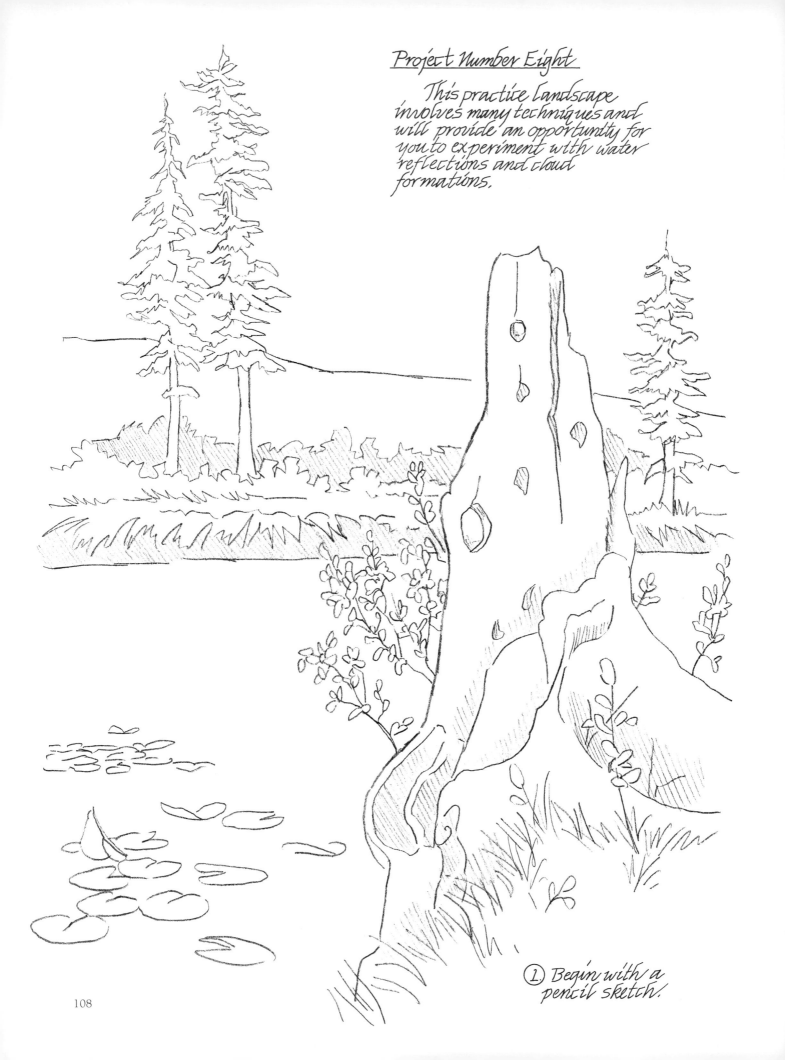

## Project Number Eight

This practice landscape involves many techniques and will provide an opportunity for you to experiment with water reflections and cloud formations.

① Begin with a pencil sketch.

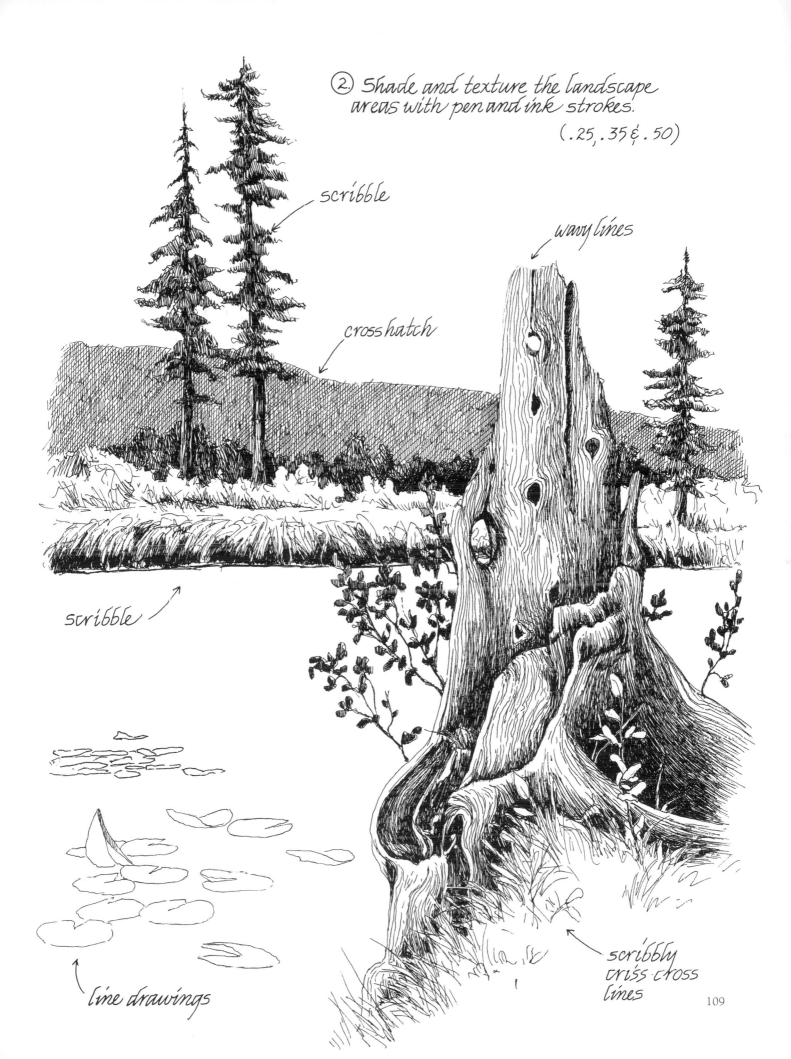

② Shade and texture the landscape areas with pen and ink strokes.

(.25, .35 & .50)

scribble

wavy lines

cross hatch

scribble

line drawings

scribbly criss cross lines

109

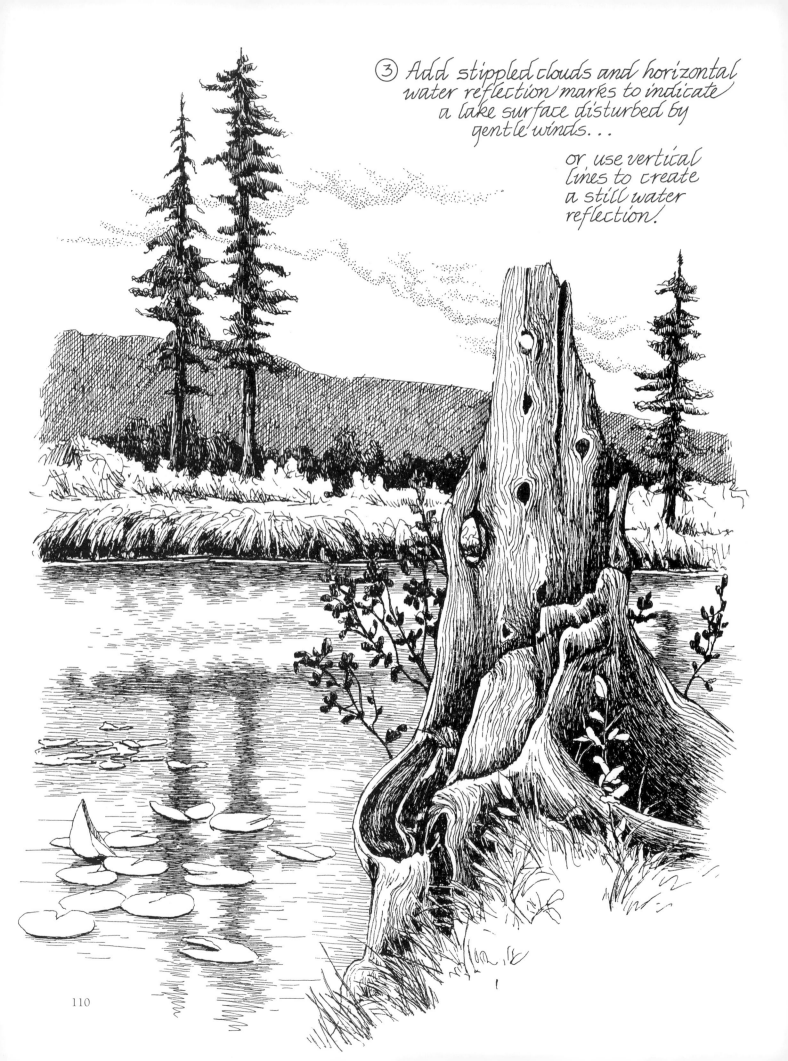

③ Add stippled clouds and horizontal water reflection marks to indicate a lake surface disturbed by gentle winds...

or, use vertical lines to create a still water reflection!

110

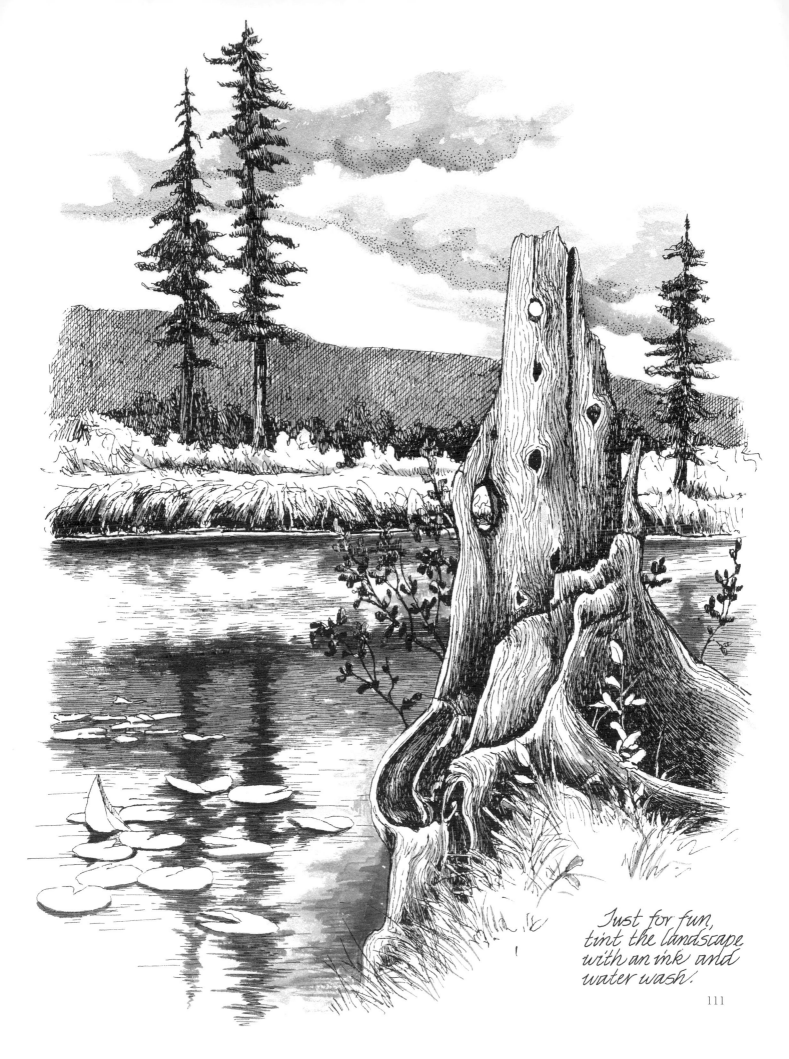

*Just for fun, tint the landscape with an ink and water wash.*

111

## Project Number Nine

Use this seascape design to explore several different texturing strokes. The appearance and mood of the drawing will change according to the chosen technique.

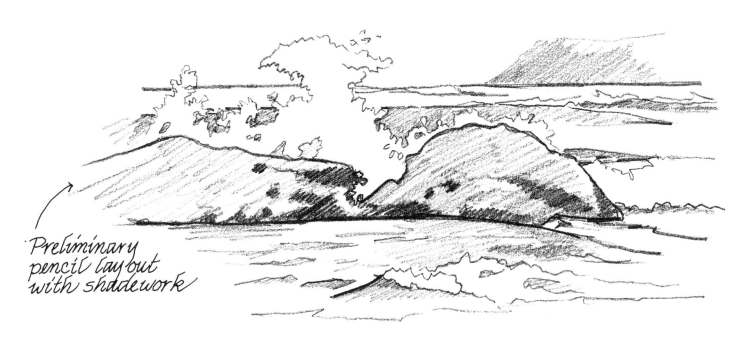

Preliminary pencil layout with shadework

loose, scribbly lines suggest wild movement and plenty of action in the scene.

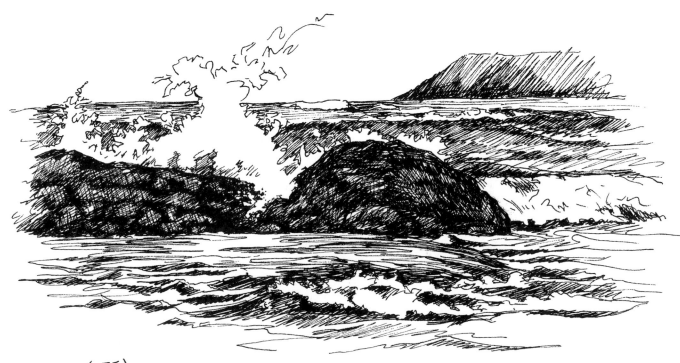

(.35)

Spray contour can be defined with a minimal amount of lines.

(.25 & .35)

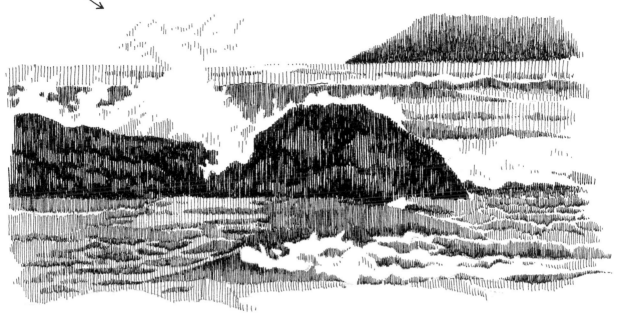

Parallel line work depicts a quieter mood. Perhaps an early morning setting, before the mist has burned off the water.

Stippled spray looks very delicate.

Stippling takes some of the harshness from the waves, and allows subtle contours and a look of volume in the surf.

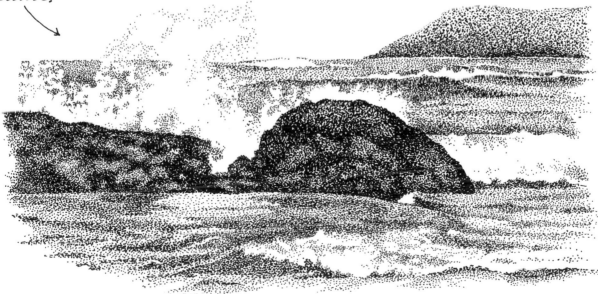

Remember to maintain good value contrast, whatever texturing technique you use.

(.25, .30 & .35)

## Project Number Ten

Sketch your own pet portrait or use my drawing of a Weimaraner to practice the depiction of short, fine hair.

Pay special attention to hair length and direction (indicated by arrows.)

Value changes in the dog's coat are marked by outlining the areas subtly with criss-cross fur strokes. Make sure the hair-stroke outlines are heading the right direction.

R

R

R

Hair length should not exceed the outlines indicated above.

The hair ridge areas where hairs lying in different directions come together, are marked with the letter R.

Allow the hairs to meet along the ridge line, but do not let them cross hatch into each other.

114

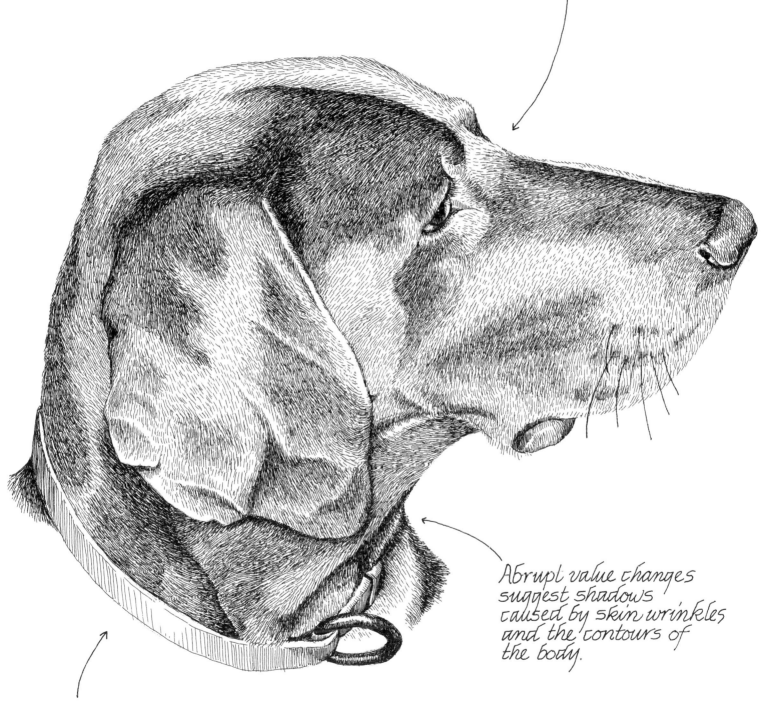

Value changes from light gray to medium gray, the edges softly blended, give the Weimaraner's coat a glossy appearance.

(.18, .25)

Abrupt value changes suggest shadows caused by skin wrinkles and the contours of the body.

Note how value contrast was used to depict the veins in the ear, adding to the realistic look of the animal.

## Project Number Eleven

Re-sketch this Bald eagle or use a similar bird design and stroke on a smooth coat of feathers. Complement your bird with a background of contrasting values and textures.

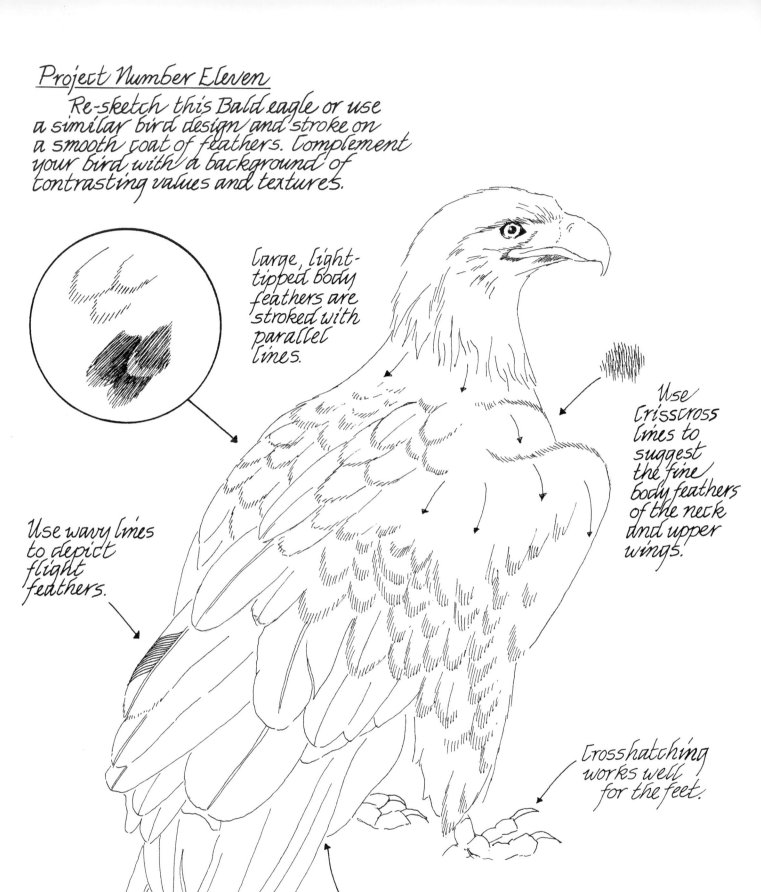

Large, light-tipped body feathers are stroked with parallel lines.

Use crisscross lines to suggest the fine body feathers of the neck and upper wings.

Use wavy lines to depict flight feathers.

Crosshatching works well for the feet.

On white feathers, only the shadow areas are textured.

A contrasting background defines the edges of the subject, bringing it into better focus. Note that the white head and tail rests against the darkest portions of the background.

Varied background textures of scribble, crosshatch and crisscross lines add interest as well as contrast.

Nib sizes .25, .30 and .35 were used.

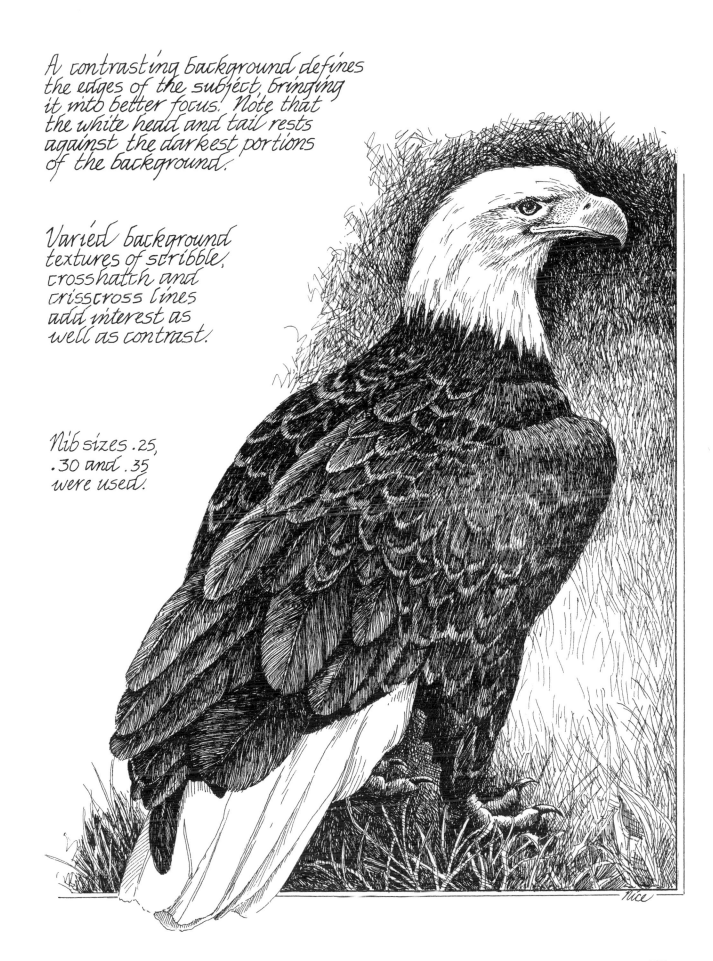

## Project Number Twelve

Loosen up your work with some scribbly quick sketches of animals in action. Work from life or from photos you have taken yourself so that the subject is familiar to you. Limit your quick sketches to one or two minutes and keep them simple.

Perfection is not a part of this project!

① Set down the large oval representing the chest. Tilt the oval to match the angle of the trunk.

② Determine the arch and length of the neck with a single line along the crest.

③ Rough in the head, neck, shoulder and rump.

④ Use a few strokes to suggest the length, shape and position of the limbs.

⑤ Add a few key shadows and finishing details.

118

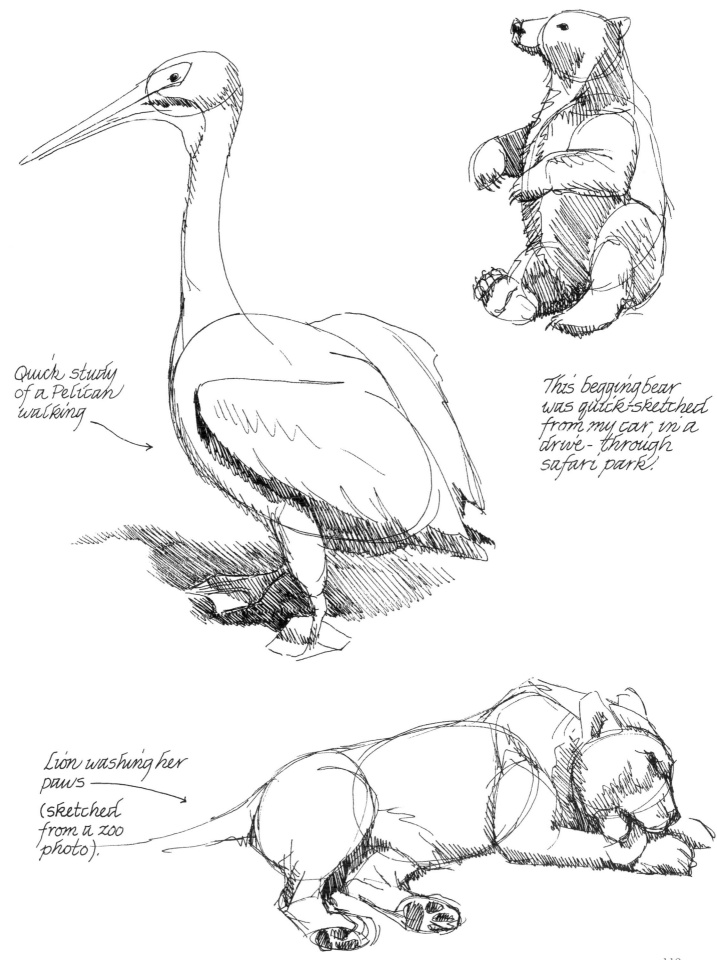

Quick study
of a Pelican
walking

This begging bear
was quick-sketched
from my car, in a
drive- through
safari park.

Lion washing her
paws
(sketched
from a zoo
photo).

119

# Project Number Thirteen

An old face is usually the most interesting to draw rich in prominent features, wrinkles and character. I'll guide you through this "Grandmother" portrait, then try your hand on one of your own.

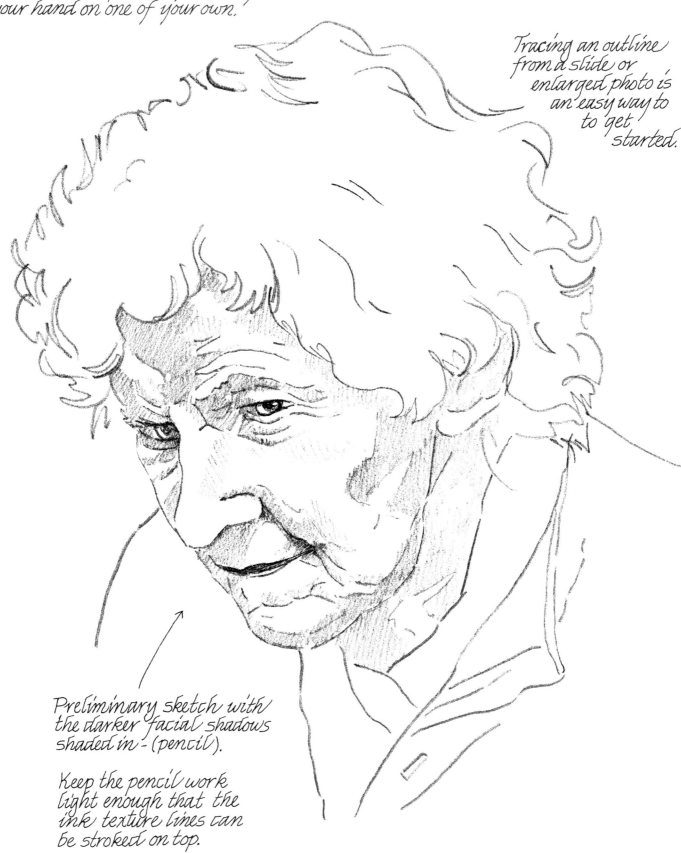

Tracing an outline from a slide or enlarged photo is an easy way to to get started.

Preliminary sketch with the darker facial shadows shaded in - (pencil).

Keep the pencil work light enough that the ink texture lines can be stroked on top.

Begin the ink work with
the eyes —
                    (.25)

highlight
dot

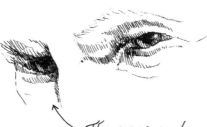

① Darken the pupils
and the outer edges
of the iris.

The nose casts
a shadow across
this eye.

② Use contour
lines to shade in
the iris, keeping
the lower left
corner a lighter
value.

③ Use loose, scribbly lines
to establish the outline
of the hair, especially
where it lies over the
face.

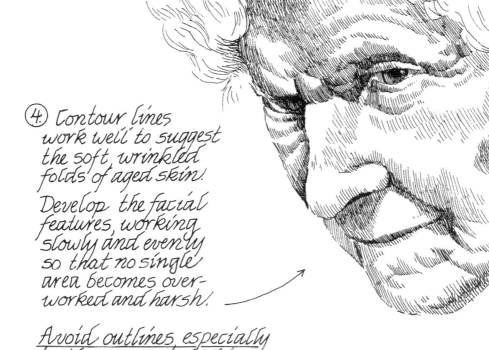

④ Contour lines
work well to suggest
the soft wrinkled
folds of aged skin.

Develop the facial
features, working
slowly and evenly
so that no single
area becomes over-
worked and harsh.

Avoid outlines, especially
in the recesses of skin
folds.

⑤ Deepen the
shadow areas
by adding more
contour lines or
a delicate
crosshatching.

The depiction of fabric as part of a portrait composition can add both interest and textural contrast.

⑥ Texture in the old fuzzy sweater and print blouse to complete the portrait of "Grandma."

Use tightly drawn scribble lines to suggest the texture of the sweater.

Begin the floral print design with a pencil outline.

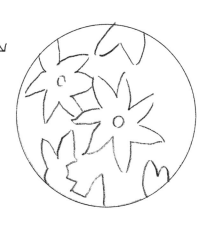
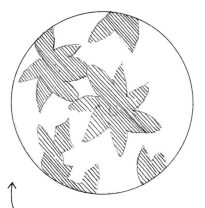
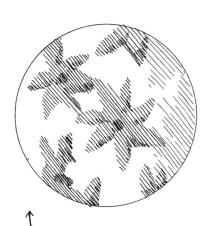

Use parallel lines to shade in the flowers.

Add flower centers and shadows with a second set of parallel lines.

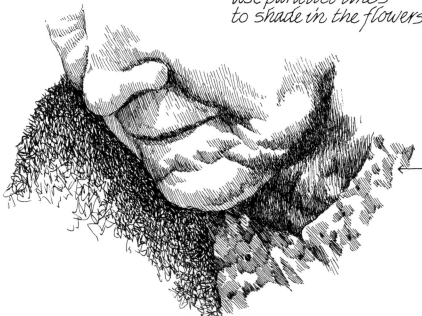

Notice how the fabric areas help define the edges of the lower face and neck, making outlines unnecessary.

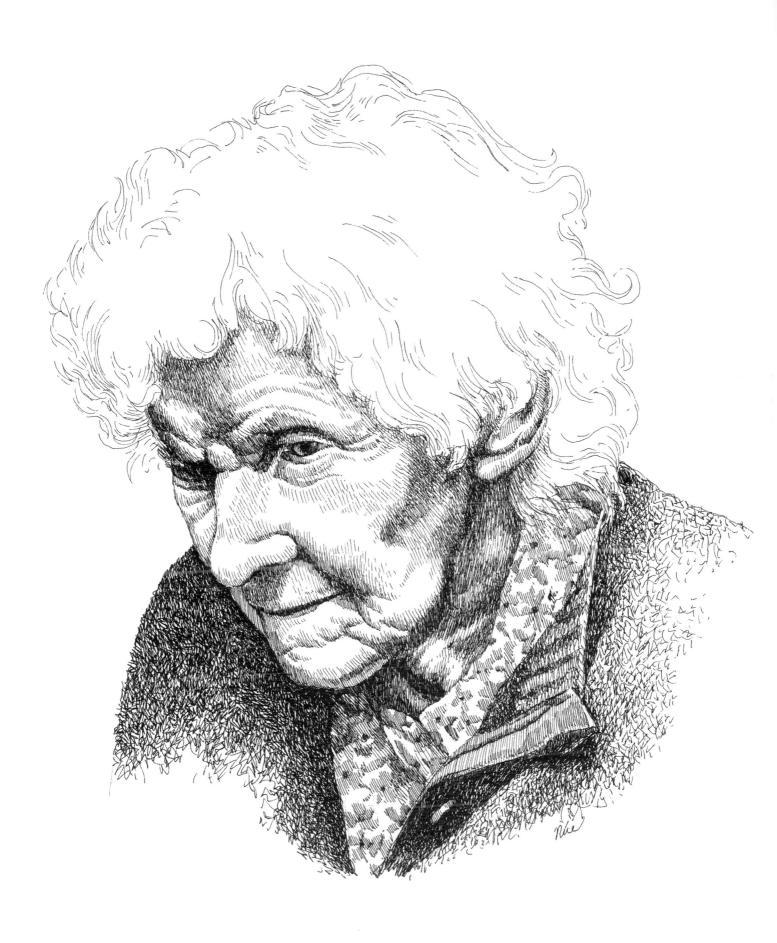

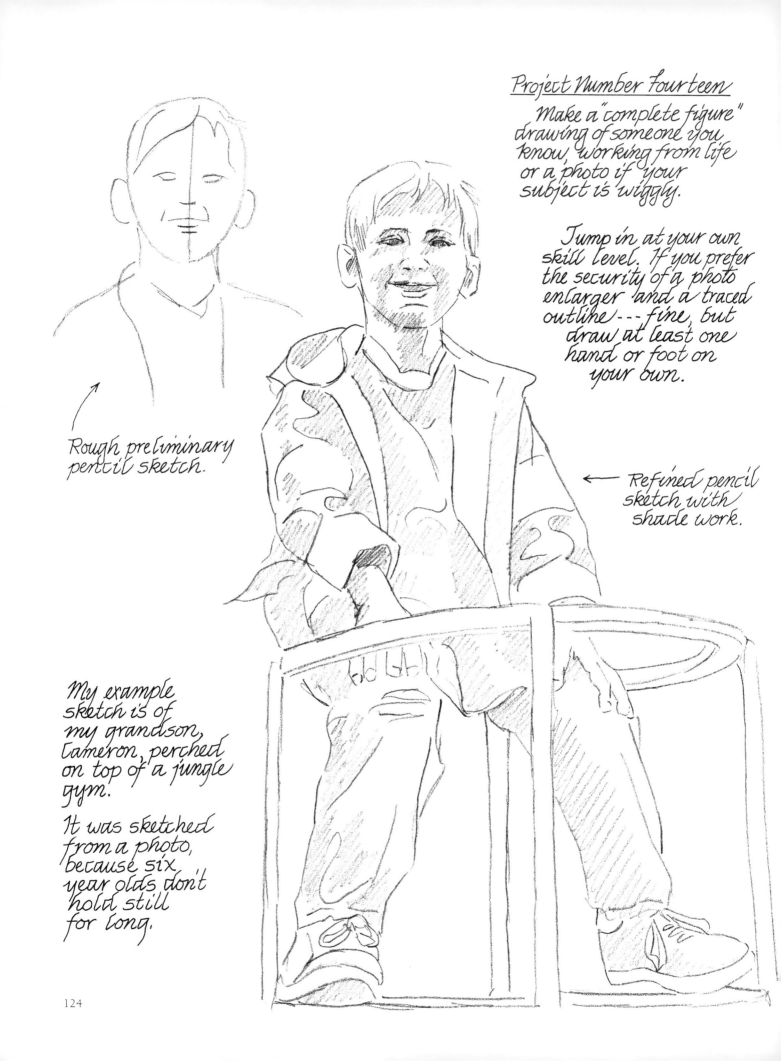

*Project Number Fourteen*

Make a "complete figure" drawing of someone you know, working from life or a photo if your subject is wiggly.

Jump in at your own skill level. If you prefer the security of a photo enlarger and a traced outline --- fine, but draw at least one hand or foot on your own.

Rough preliminary pencil sketch.

← Refined pencil sketch with shade work.

My example sketch is of my grandson, Cameron, perched on top of a jungle gym.

It was sketched from a photo, because six year olds don't hold still for long.

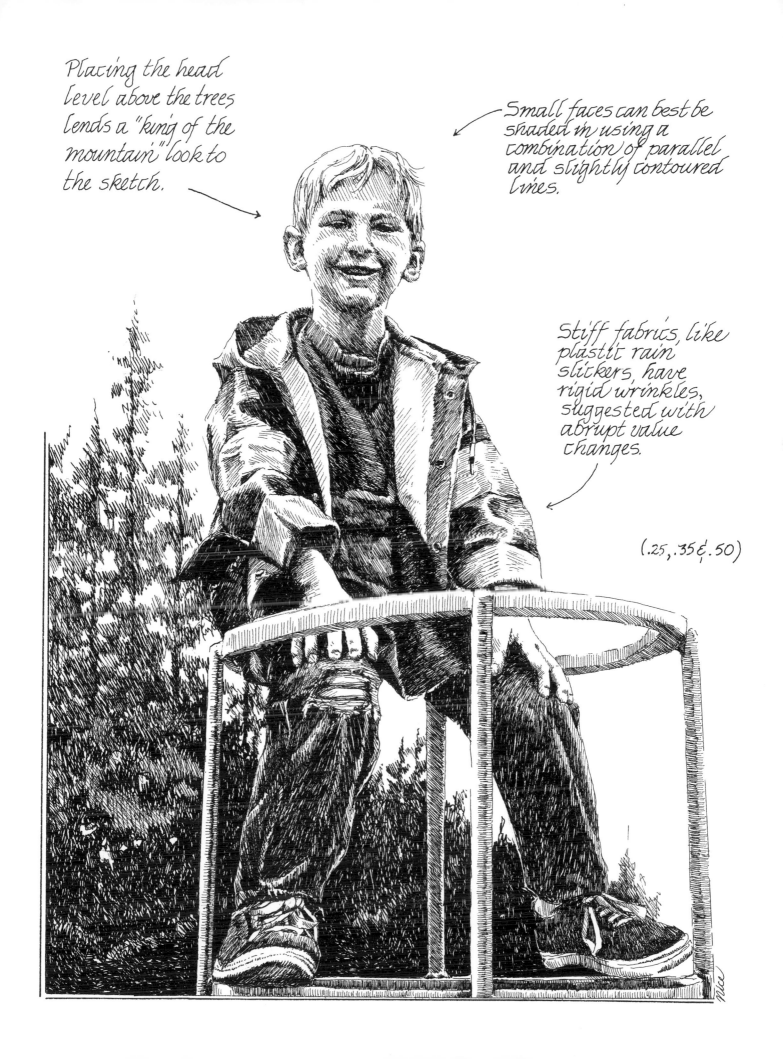

Placing the head level above the trees lends a "king of the mountain" look to the sketch.

Small faces can best be shaded in using a combination of parallel and slightly contoured lines.

Stiff fabrics, like plastic rain slickers, have rigid wrinkles, suggested with abrupt value changes.

(.25, .35 & .50)

# About the Author

Claudia Nice, a native of the Pacific Northwest, attended the University of Kansas, but gained her realistic pen and ink techniques sketching from nature. As an art consultant for Koh-I-Noor Rapidograph since 1983, and more recently Grumbacher, Claudia has traveled across North America conducting seminars, workshops and demonstrations at schools, clubs, shops and trade shows. Her oils, watercolors and ink drawings have won numerous awards and can be found in private collections across the continent.

Claudia has authored twelve successful art instruction books, including *Sketching Your Favorite Subjects In Pen And Ink* and *Creating Texture In Pen And Ink With Watercolor*, both of which were featured as main selections in the North Light Book Club.

When not involved with her art career, Claudia enjoys hiking and horseback riding in the wilderness with her husband Jim and spending time with her family and three grandchildren. She is involved in Search and Rescue as a tracker and is a reserve police officer for the Mounted Patrol in Portland, Oregon.

# Index